A Sewer Runs Through It

by Plum

RoseDog Books

PITTSBURGH, PENNSYLVANIA 15238

RoseDog Books
585 Alpha Drive
Suite 103
Pittsburgh, PA 15238
Visit our website at *www.rosedogbookstore.com*

ISBN: 978-1-63867-458-0
eISBN: 978-1-63867-554-9

A Sewer Runs Through It

Introduction

Oh New York, you can be my best friend and my worst enemy. Your magic is real, you make anything feel possible. But like all things, you have secrets, dark, dirty secrets. I hope you can forgive me for exposing them to the world, but the intention is to bring laughter and joy to those who see this and maybe get you the help you deserve in the process.

🤍 Plum

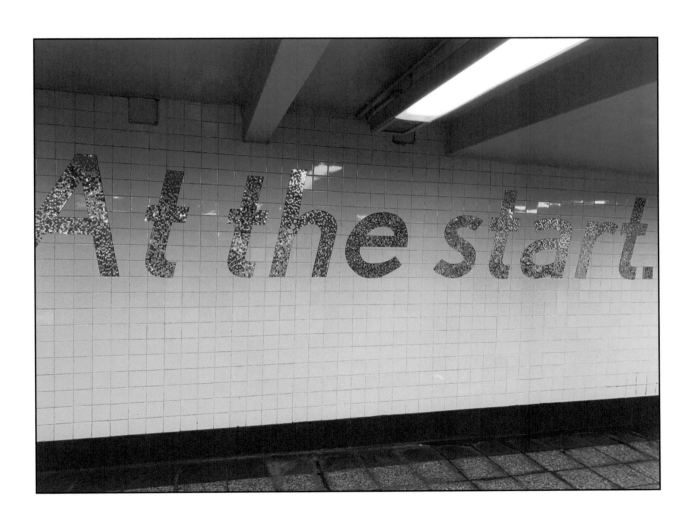

4 • Plum

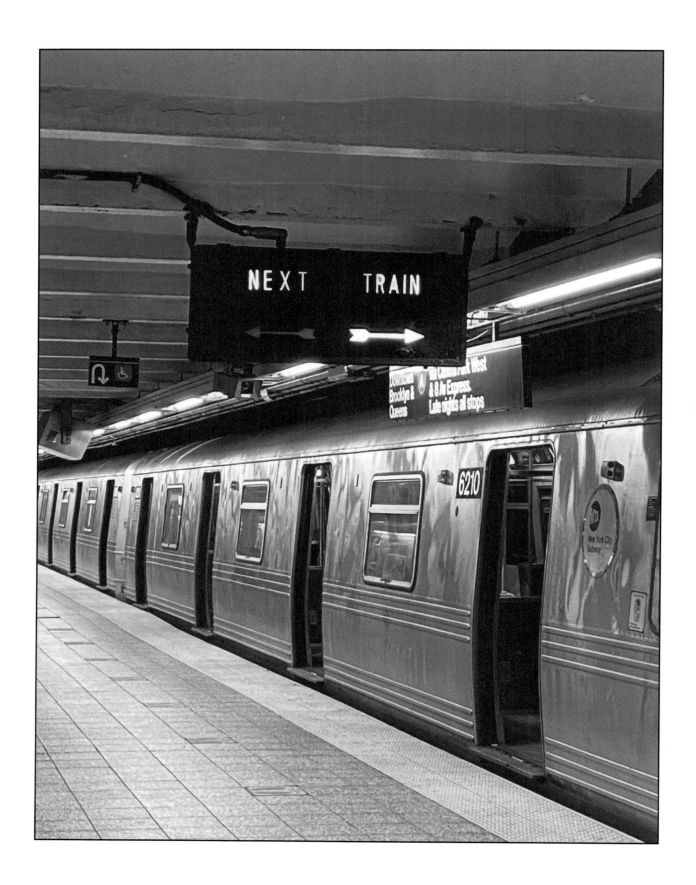

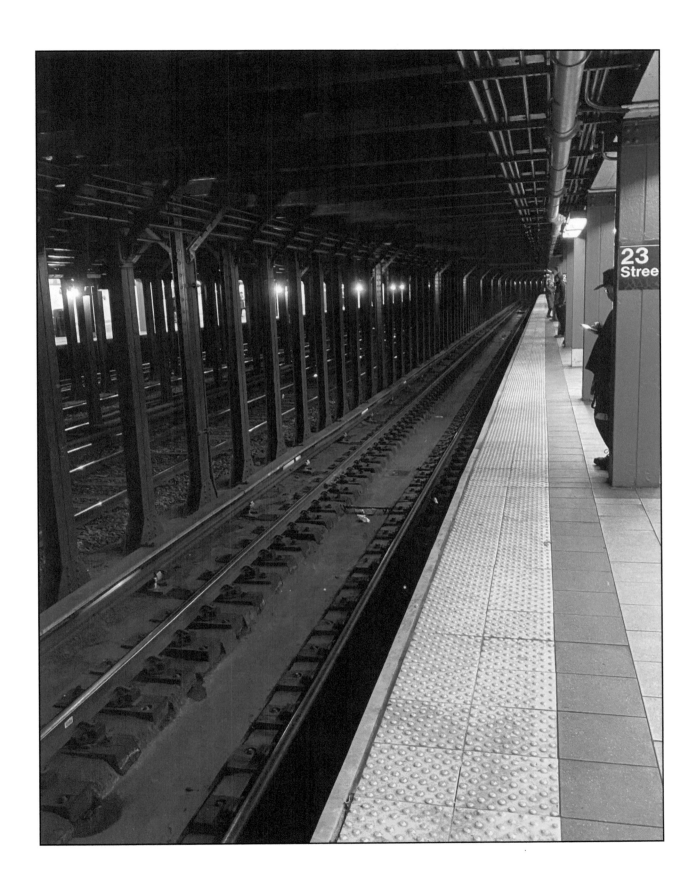

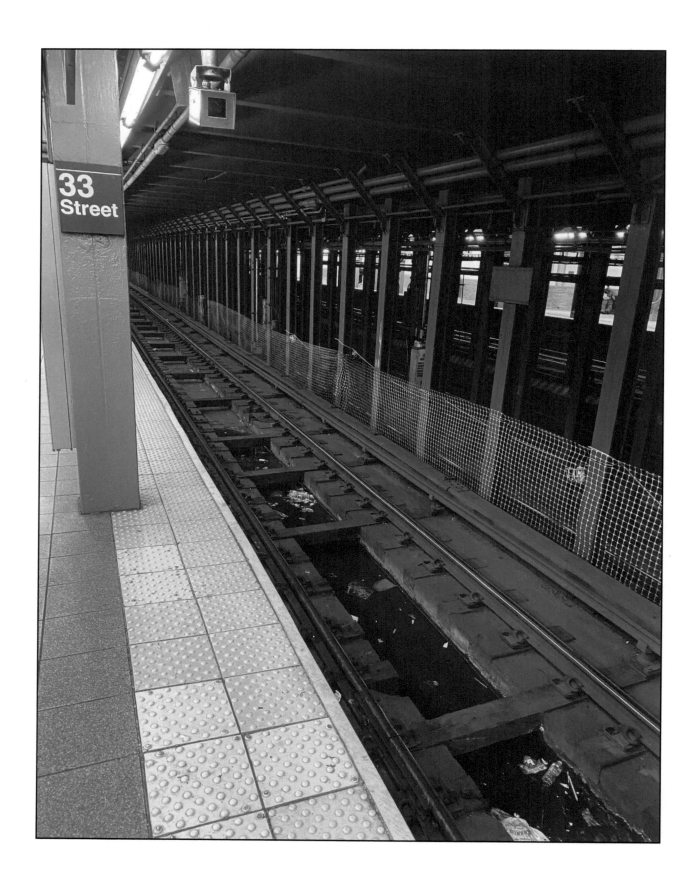

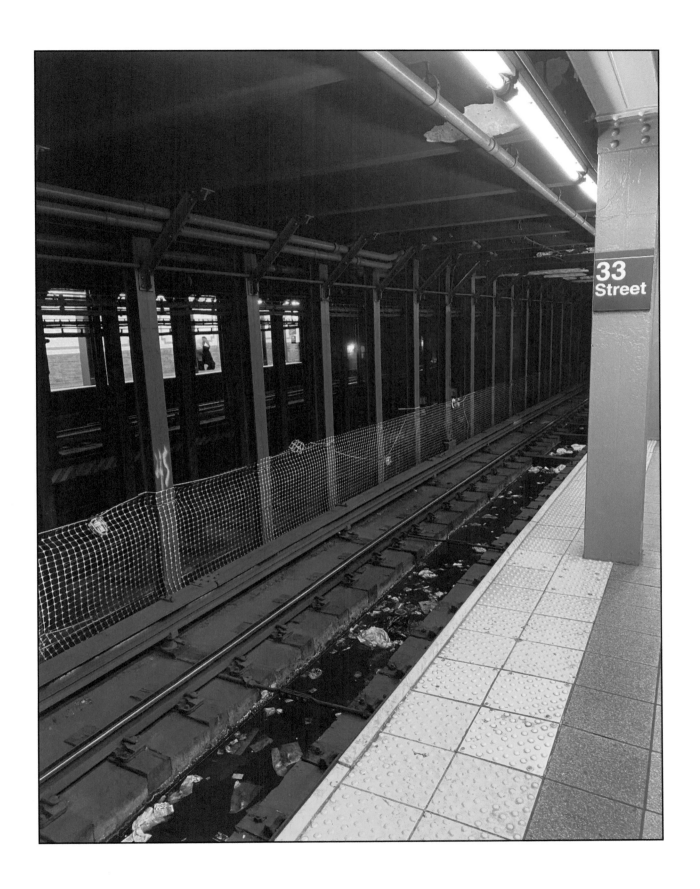

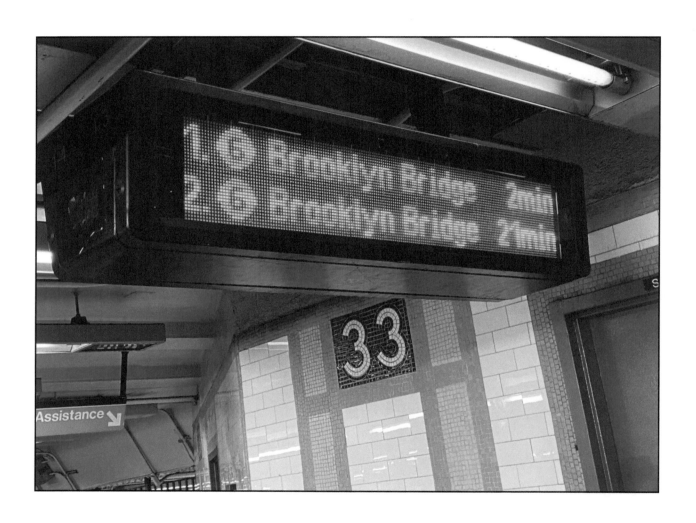

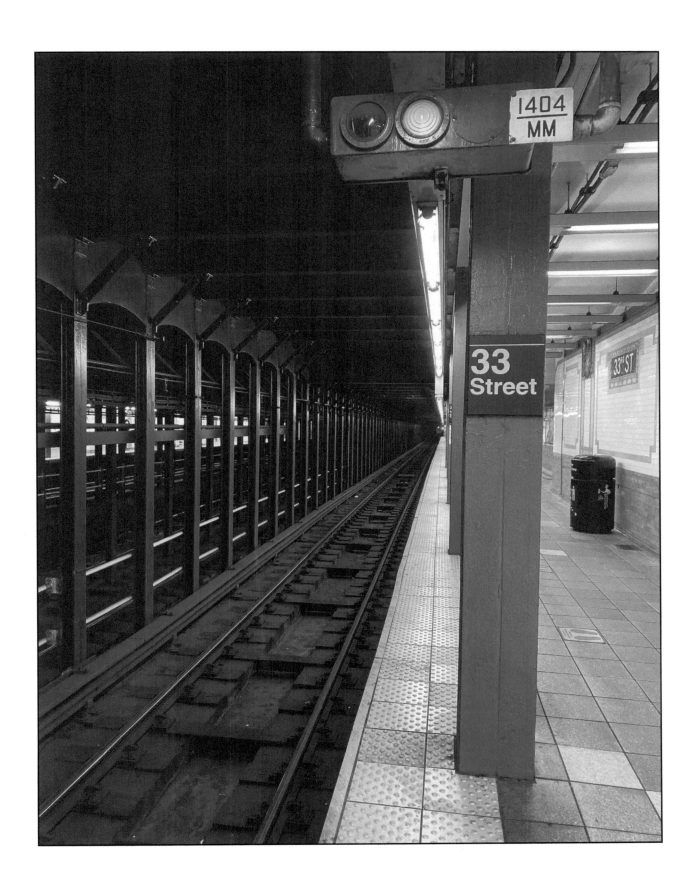

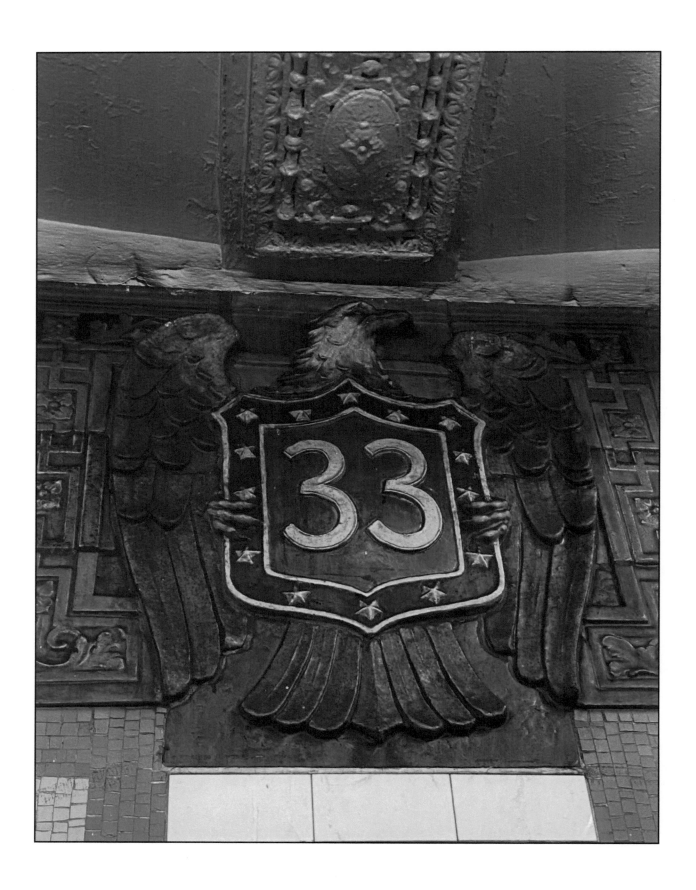

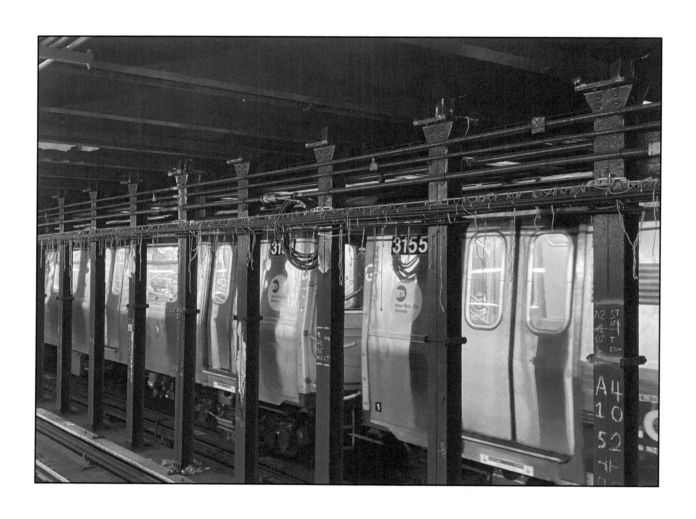

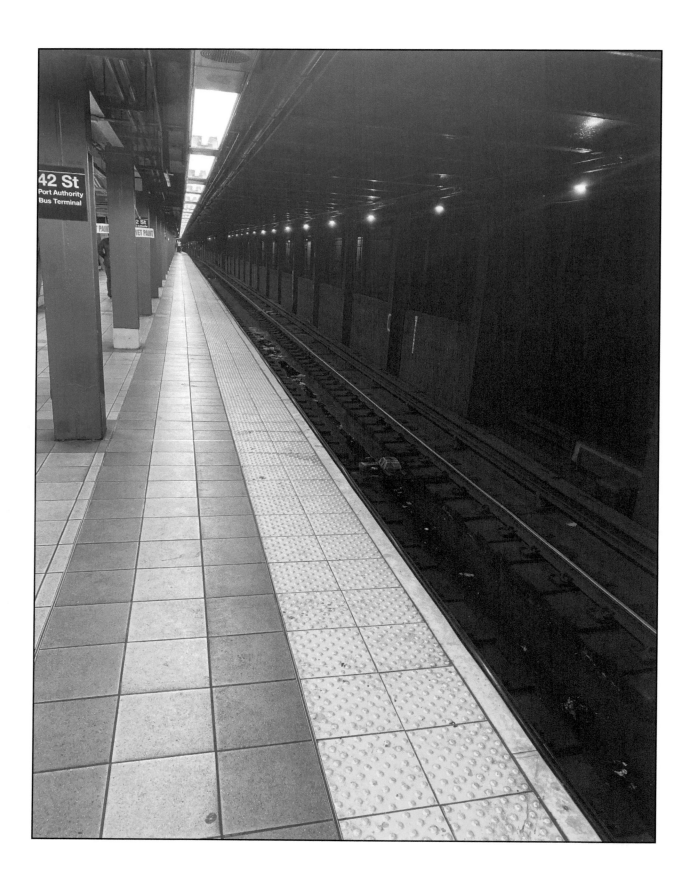

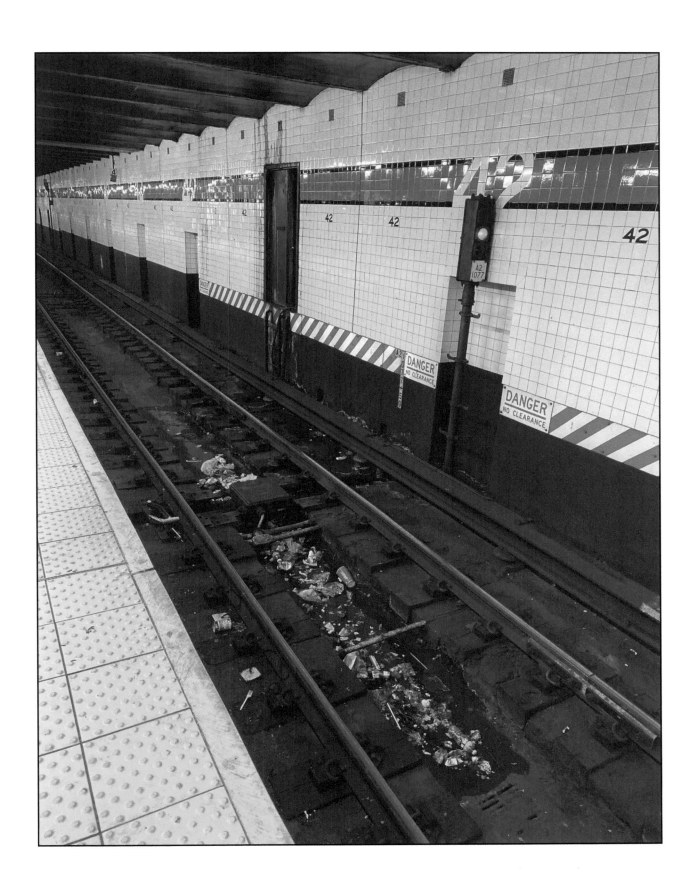

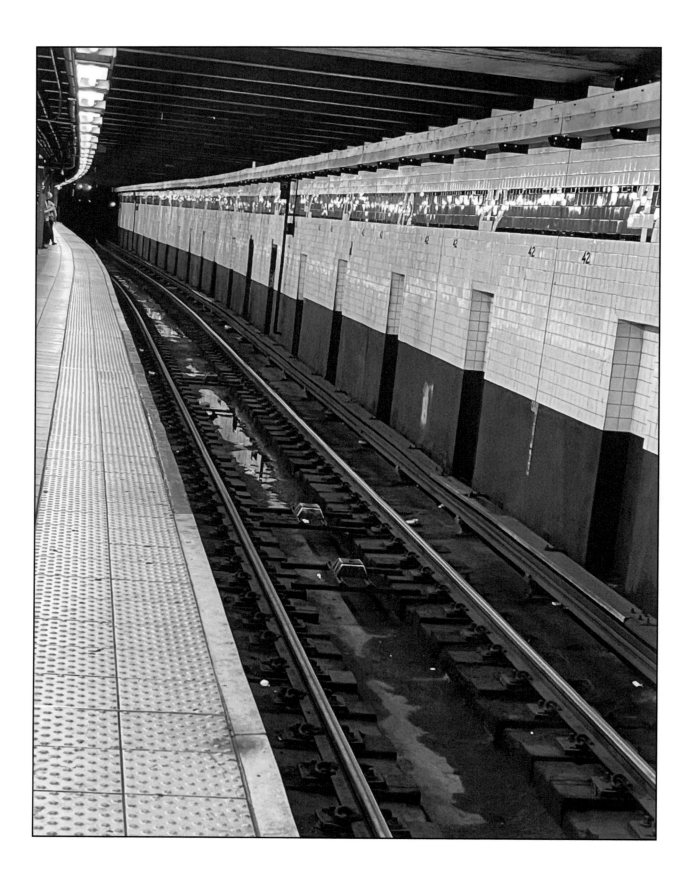

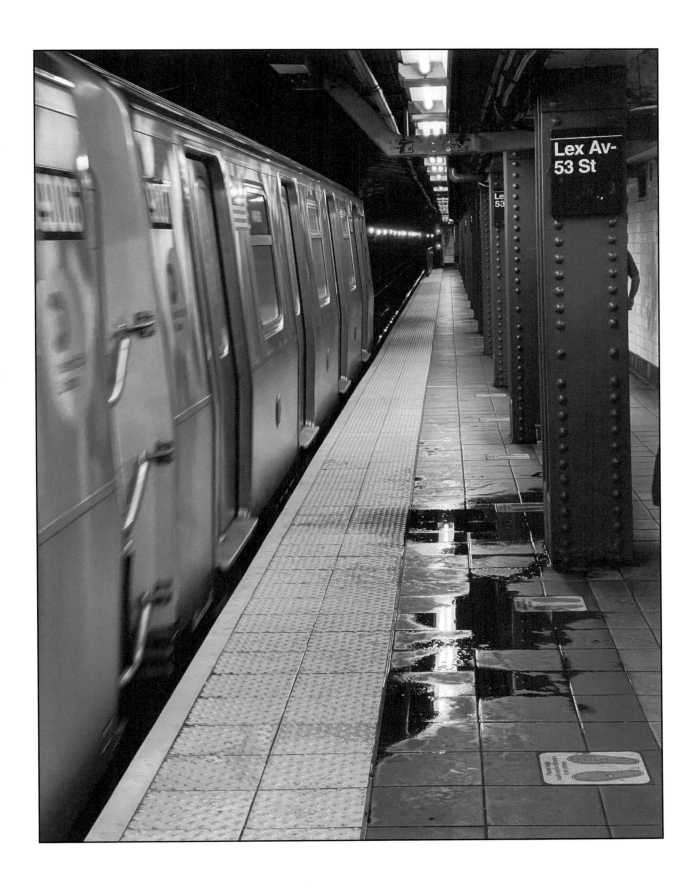

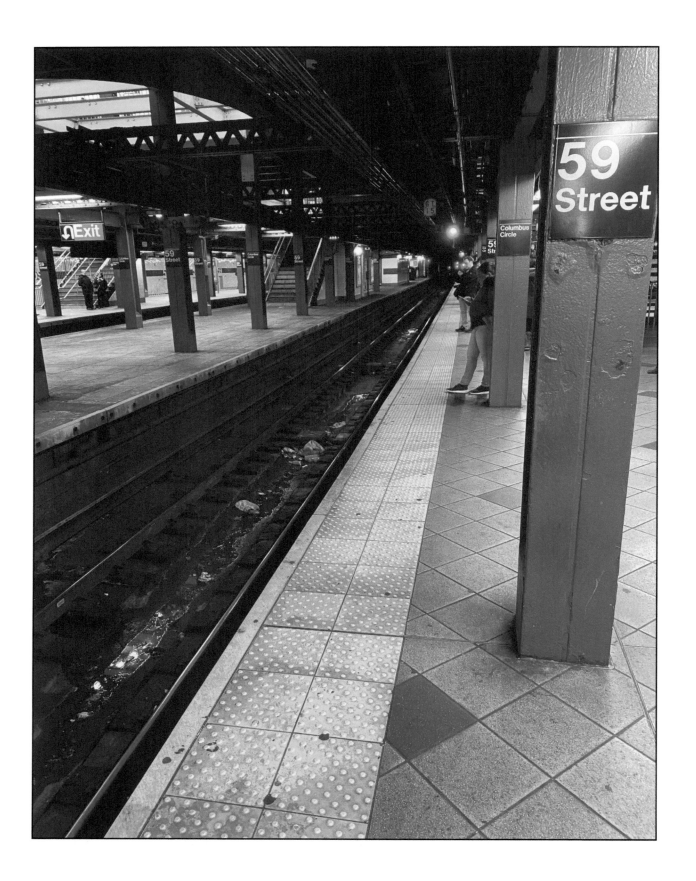

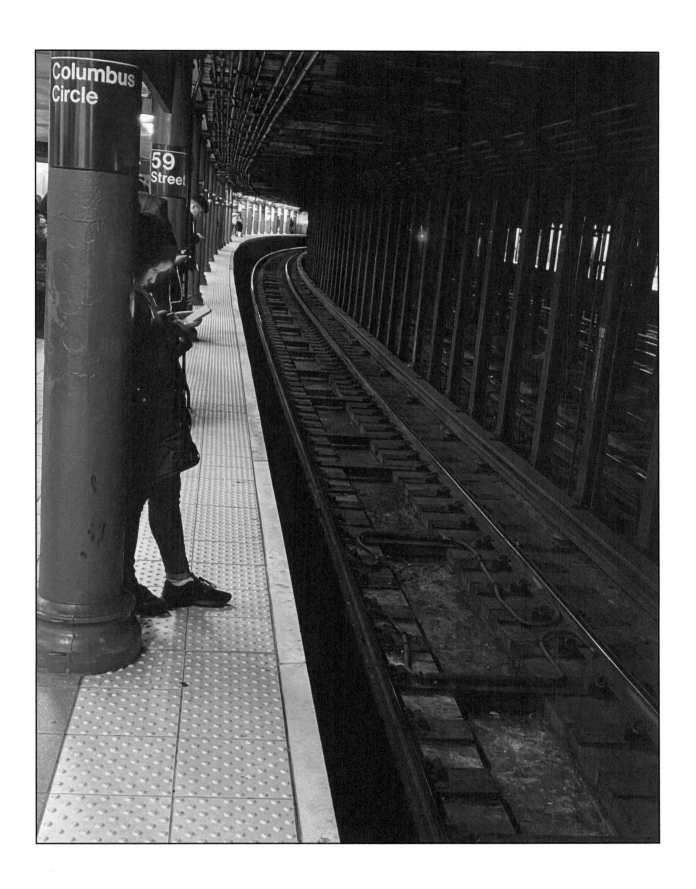

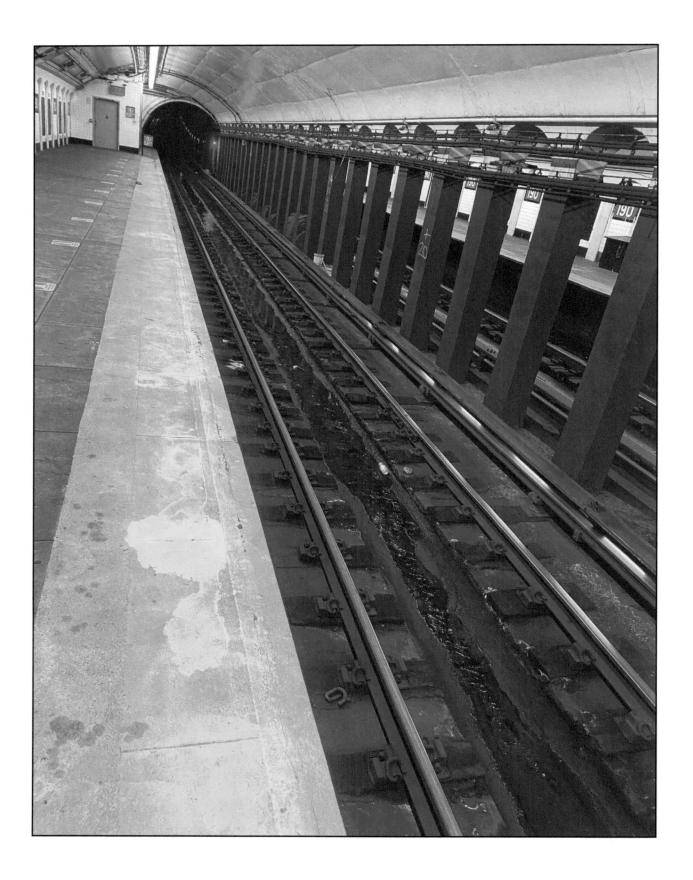

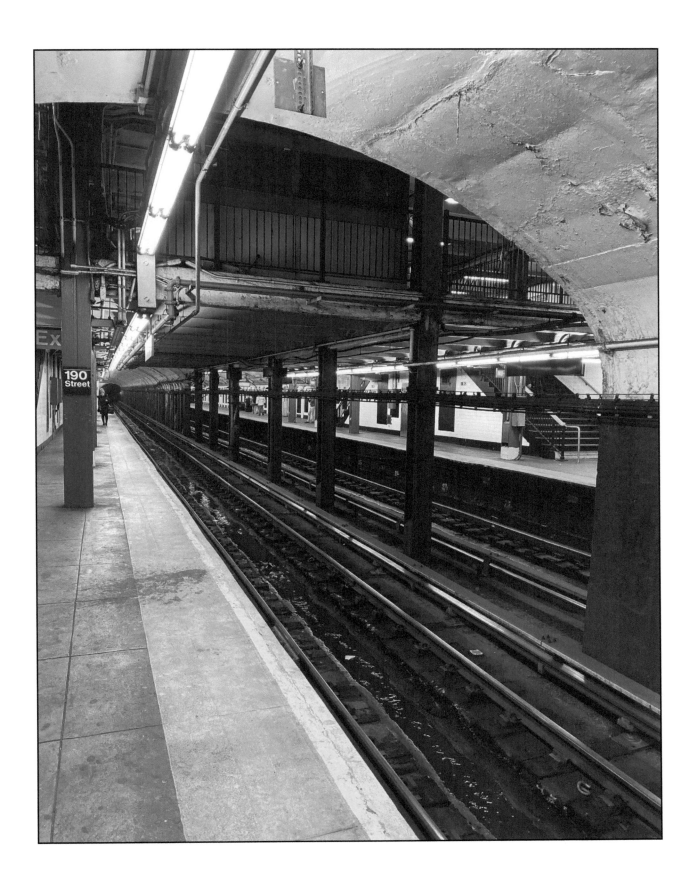

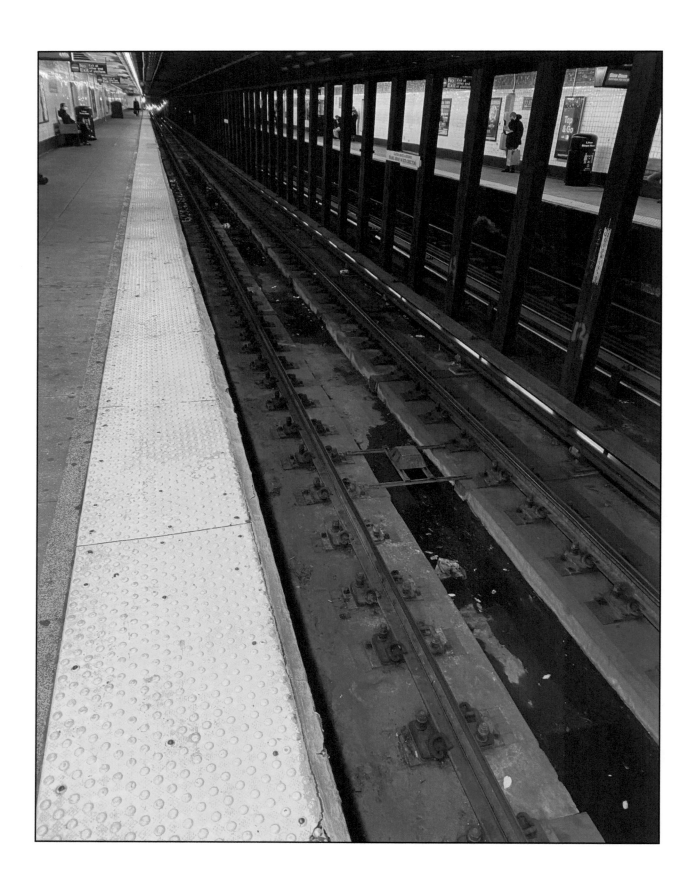

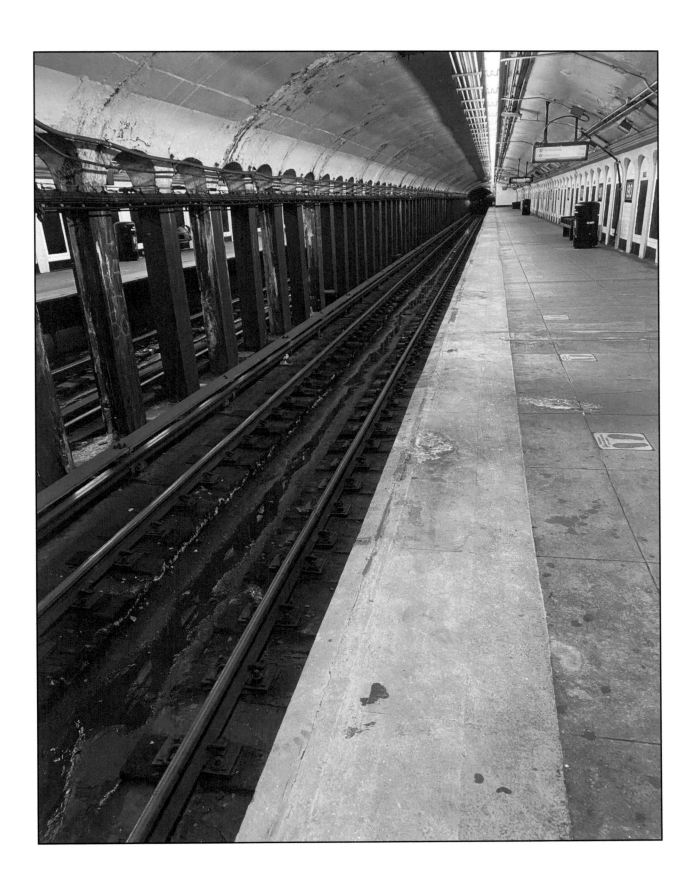

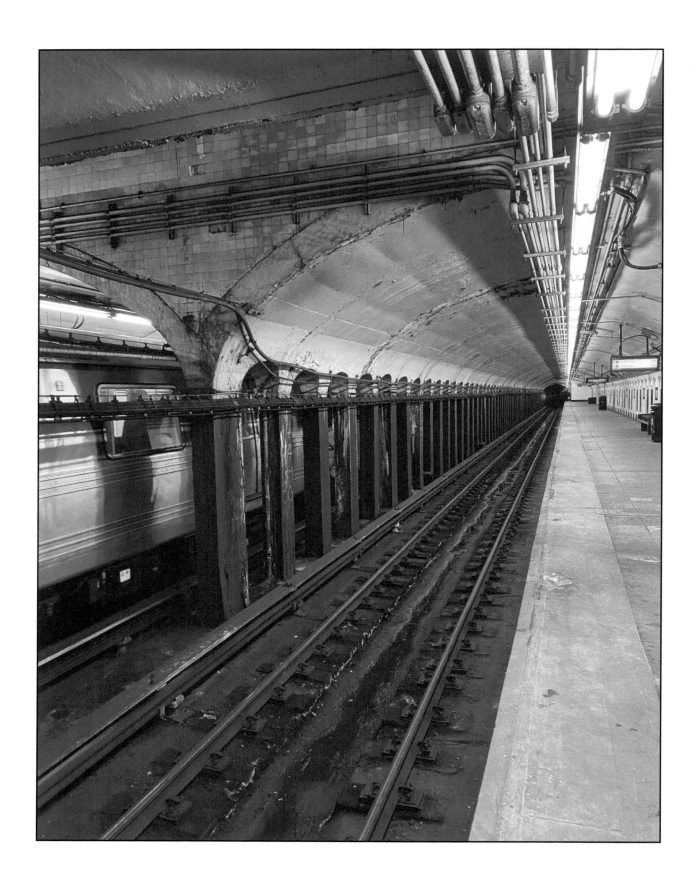

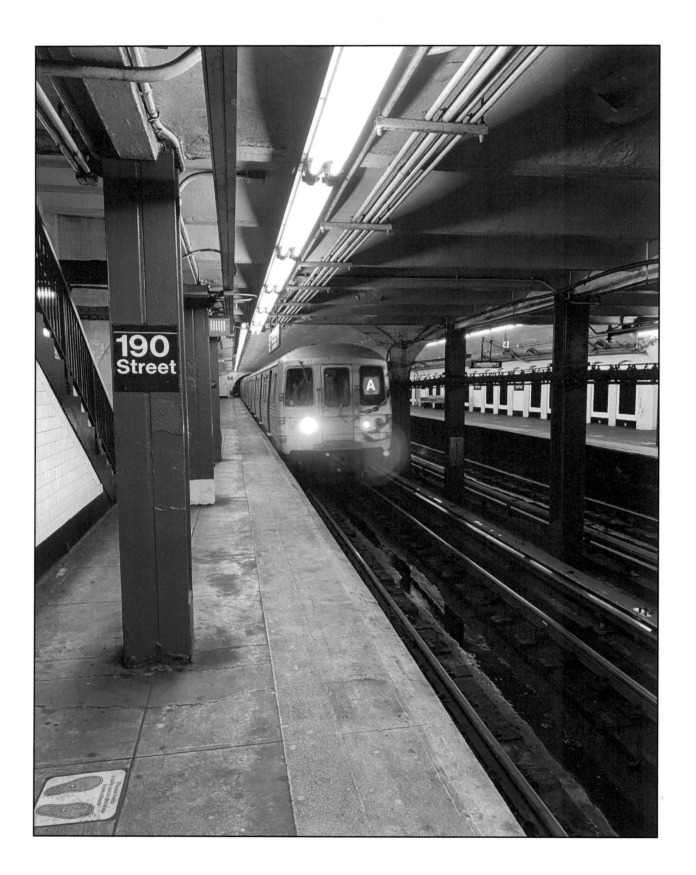

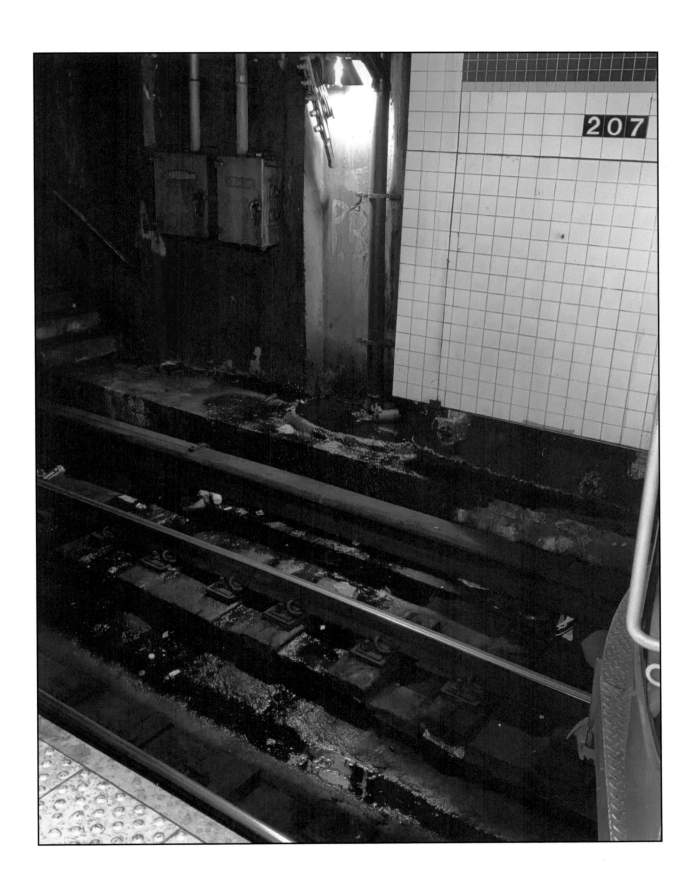

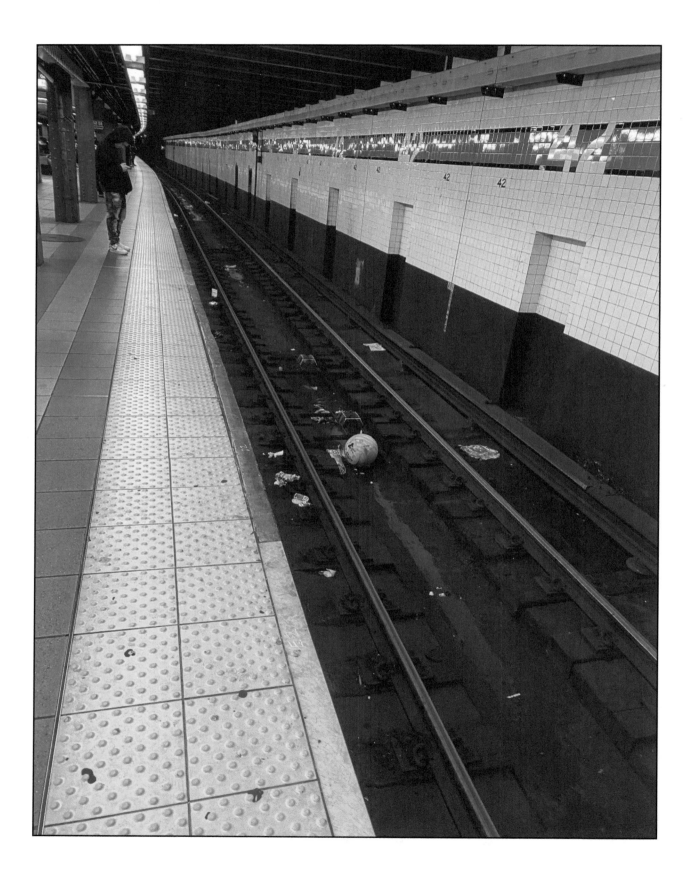

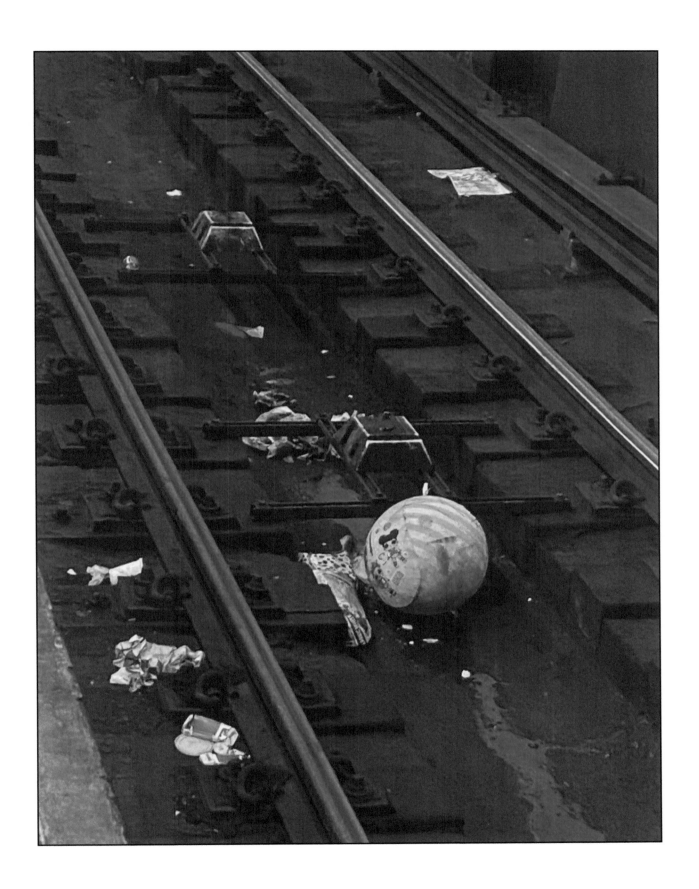

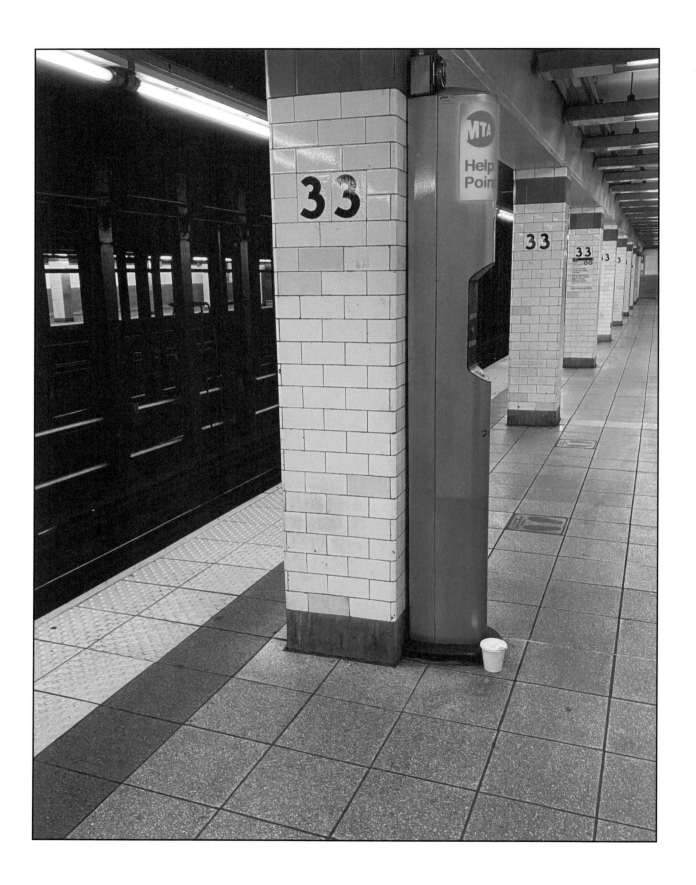

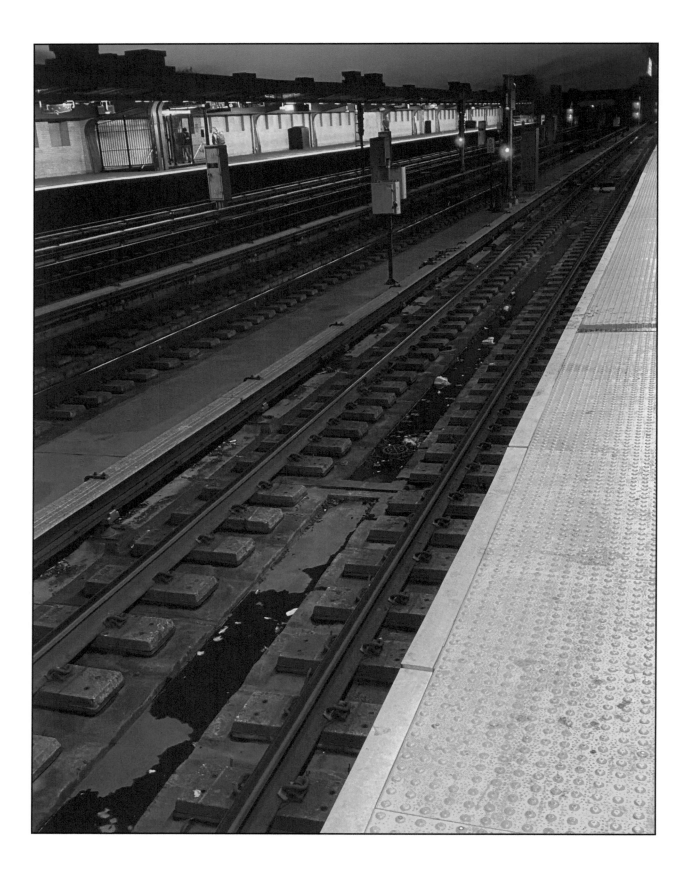

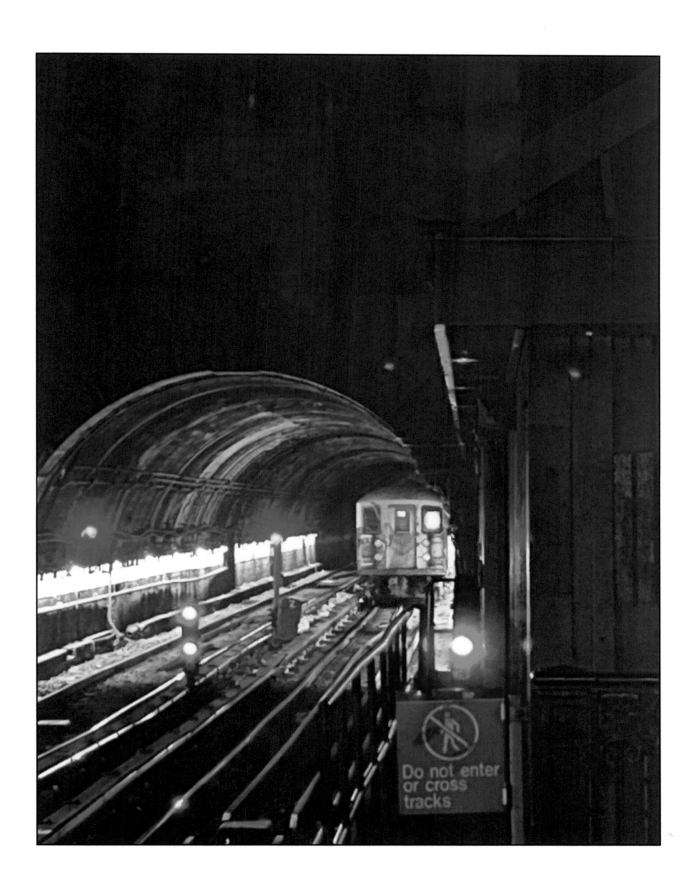

64 • Plum

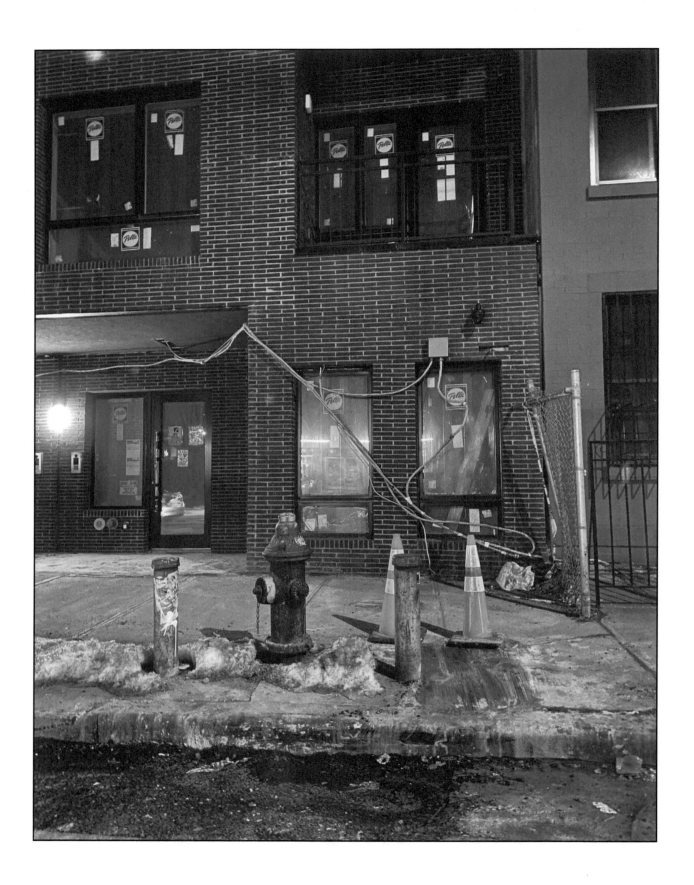

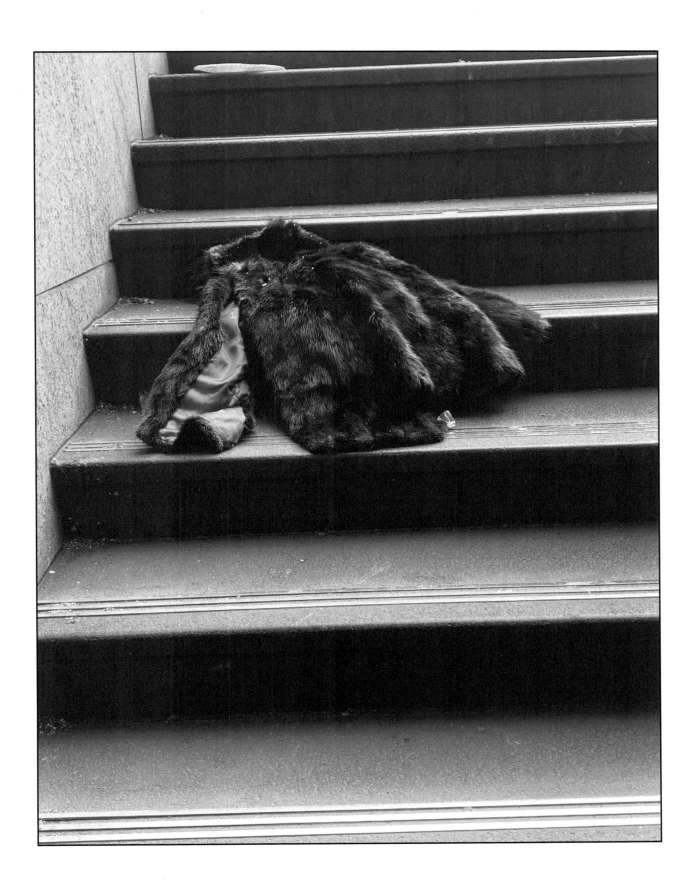

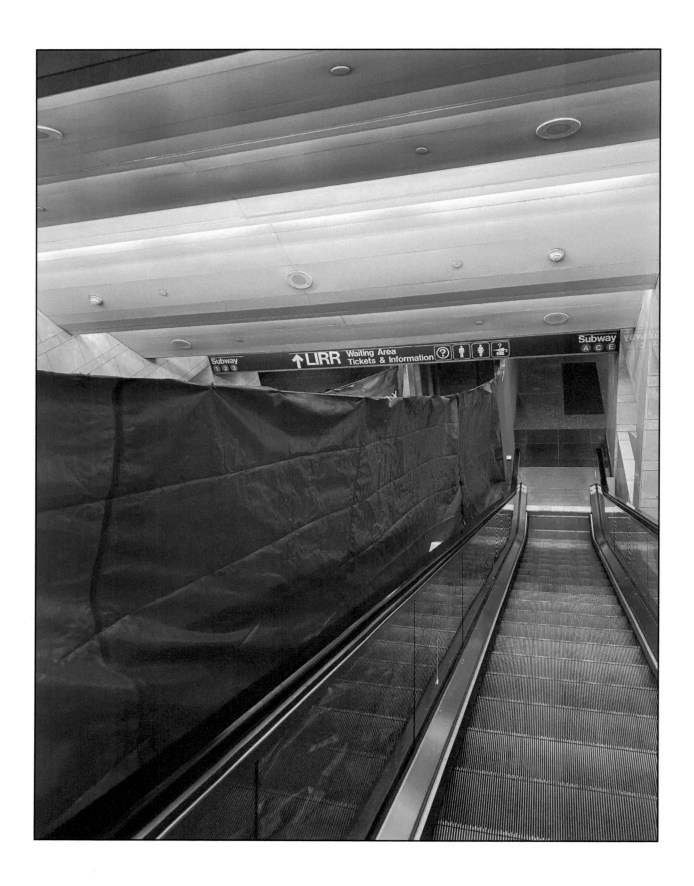

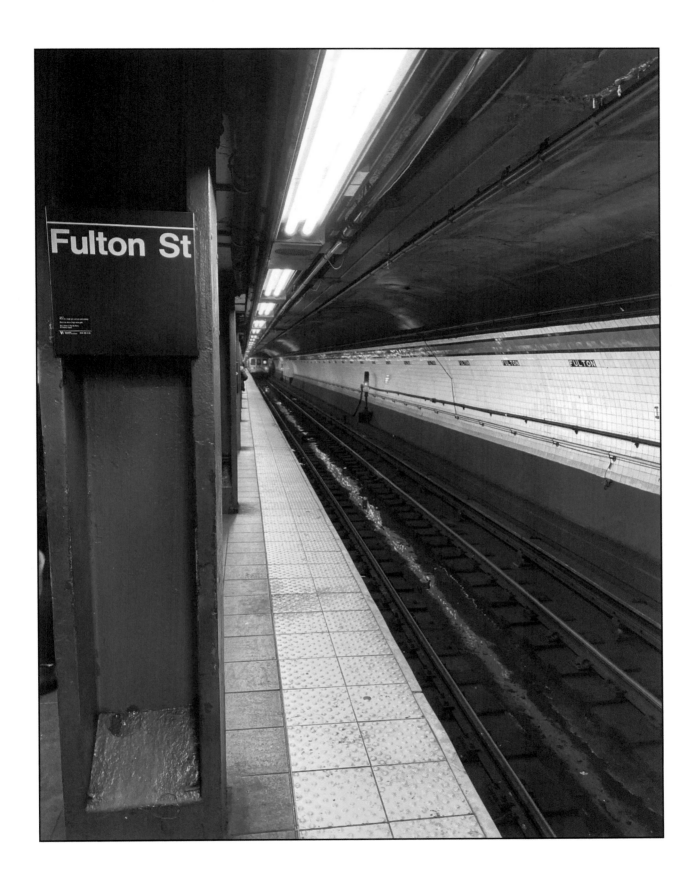

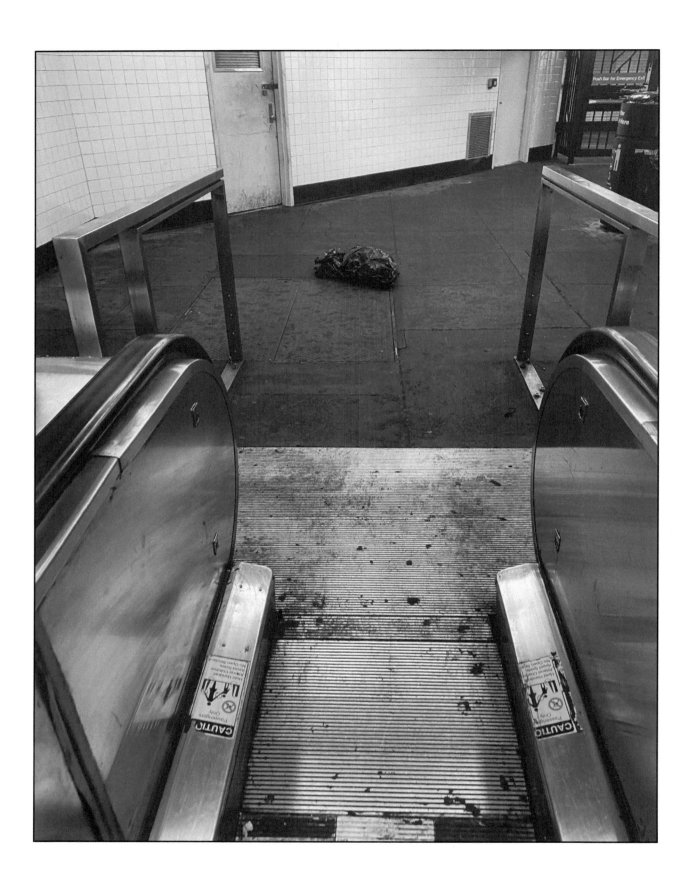

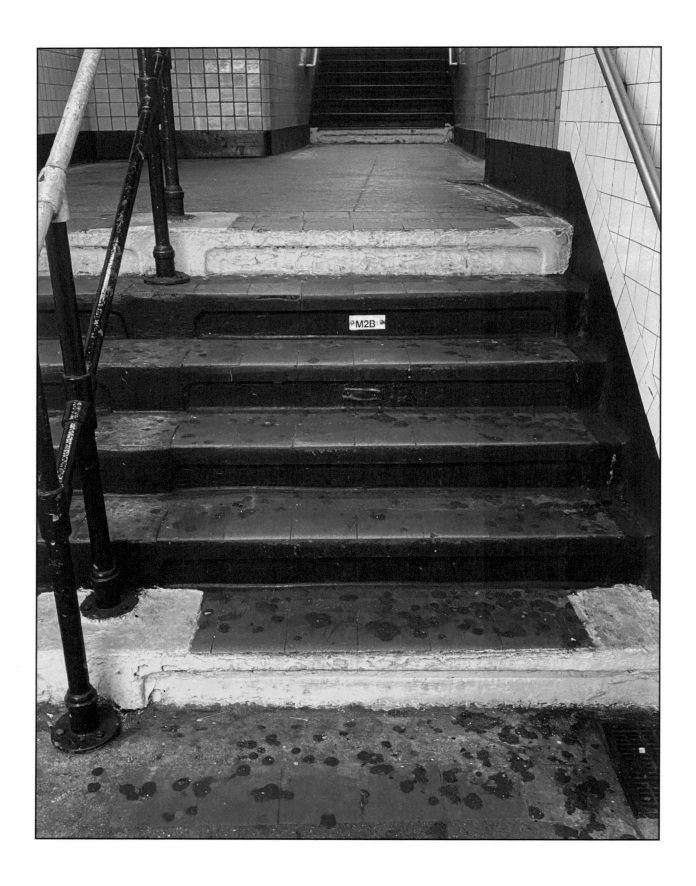

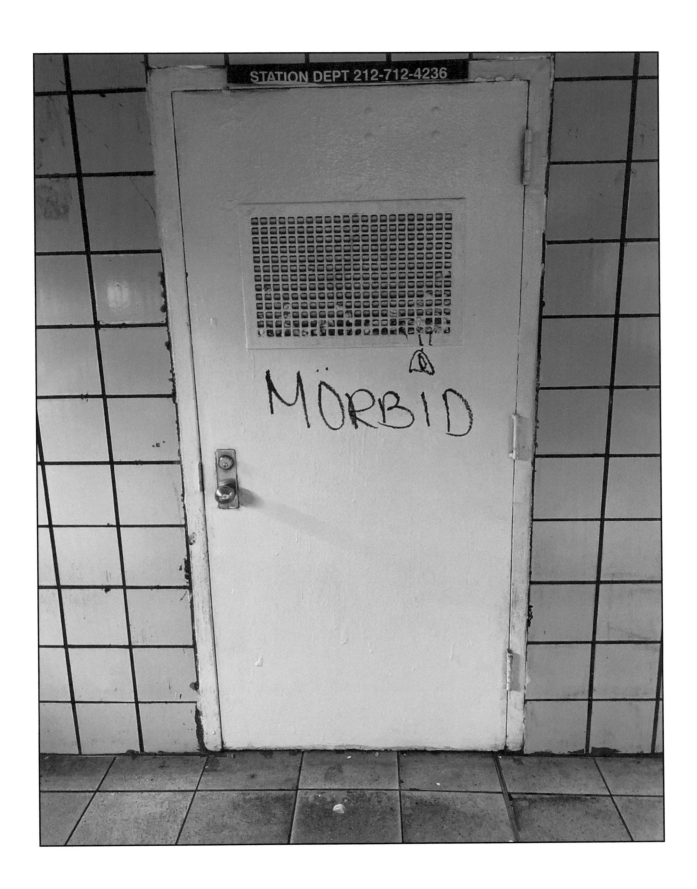

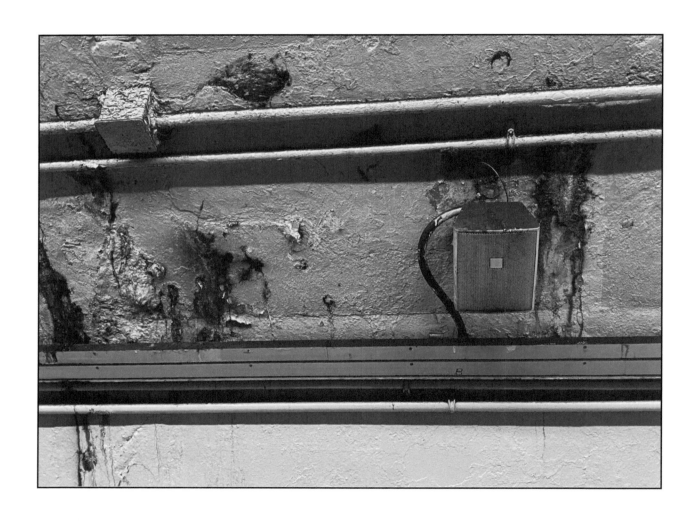

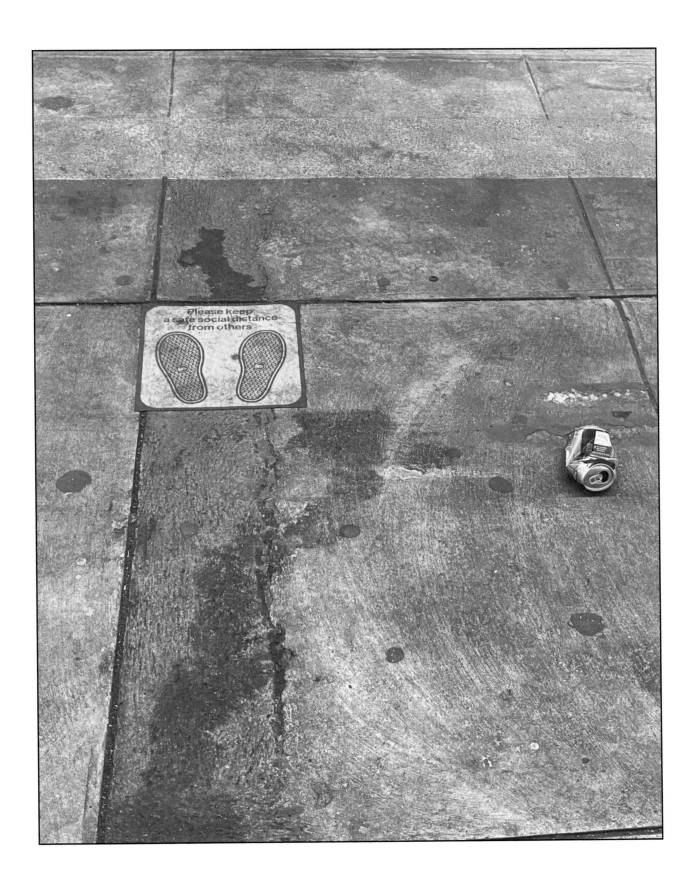

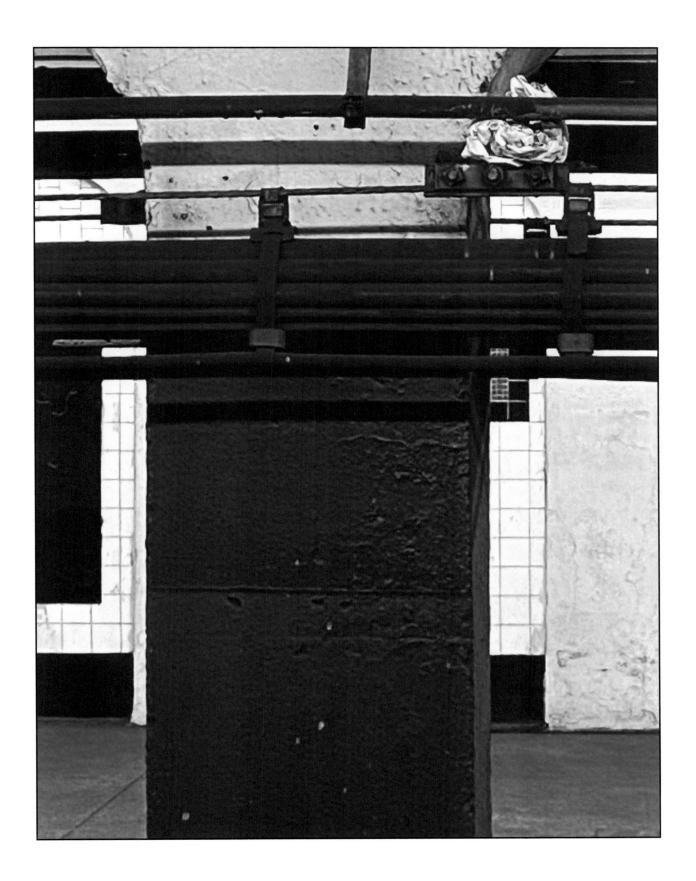

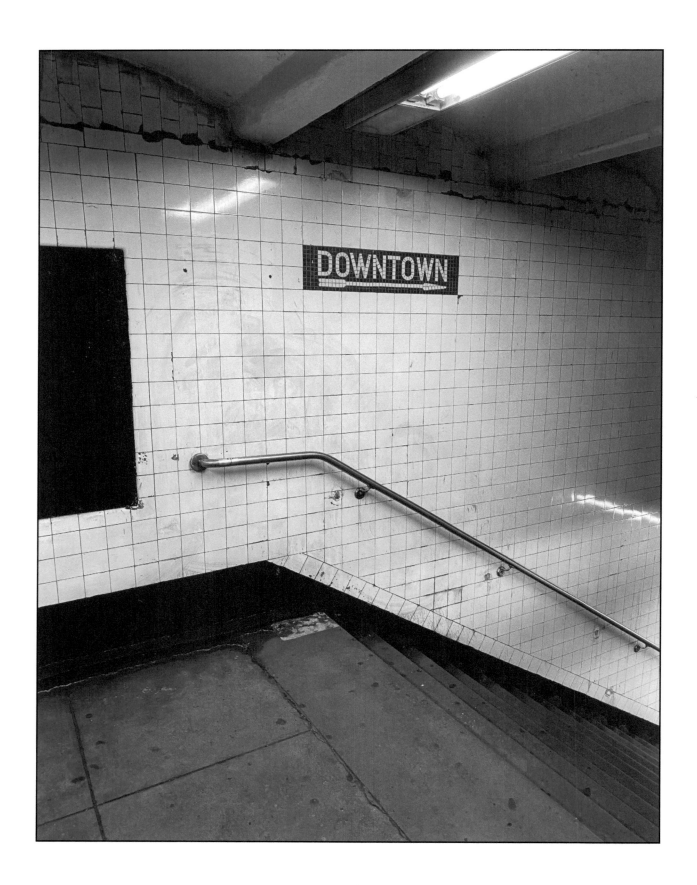

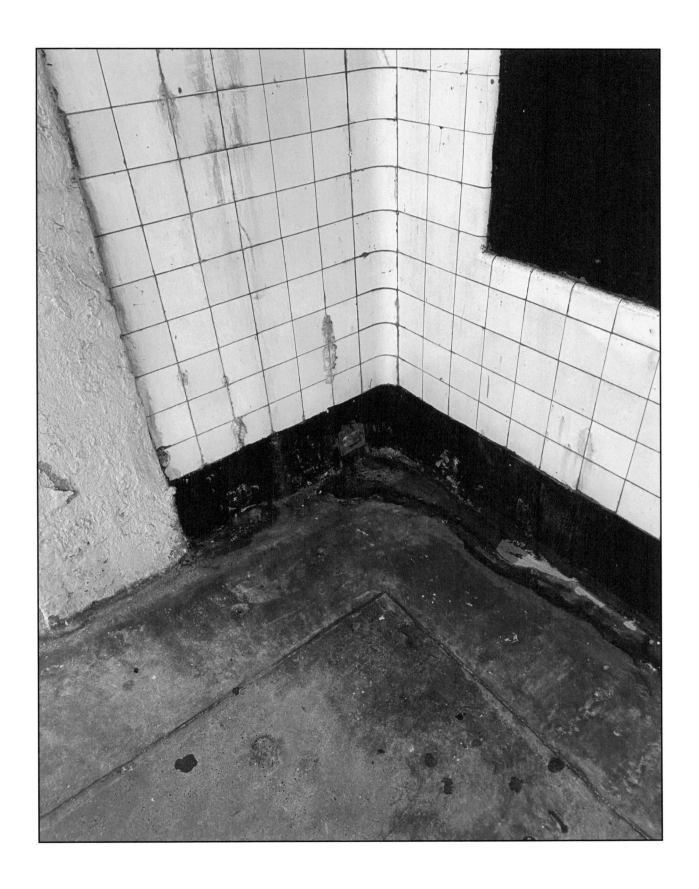

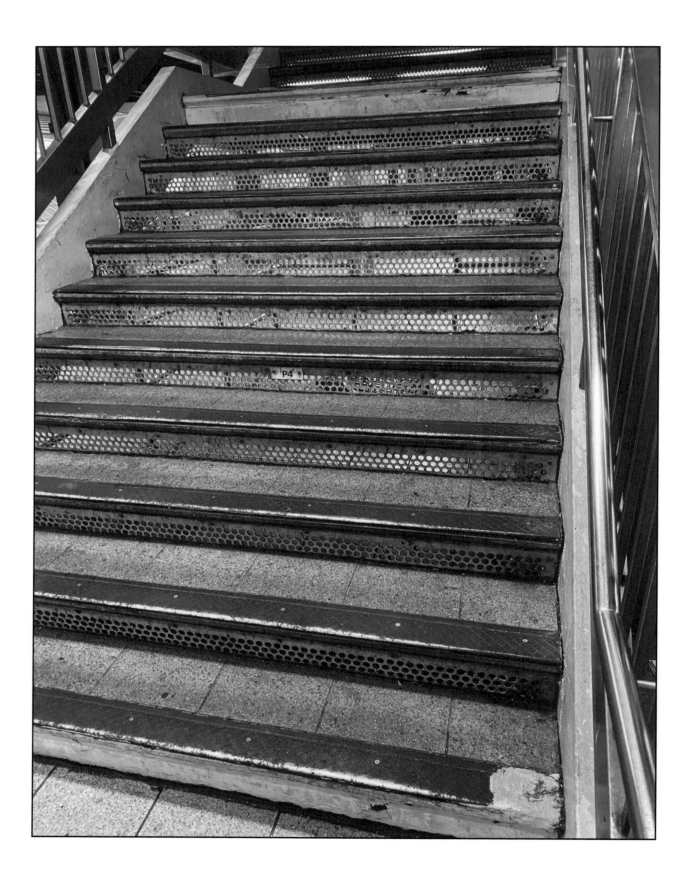

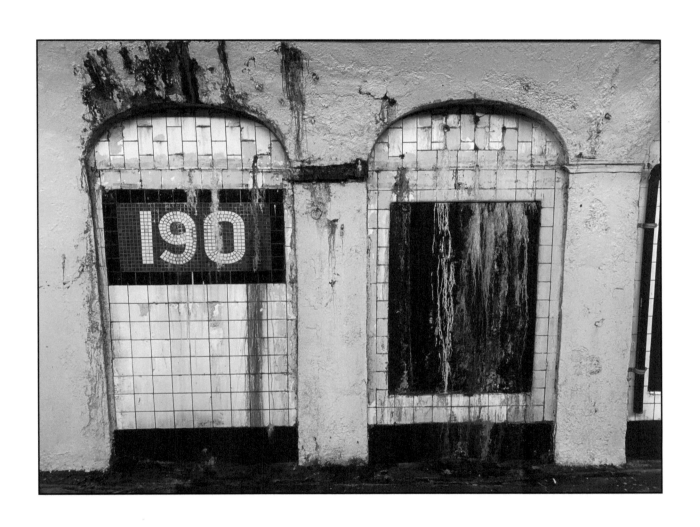

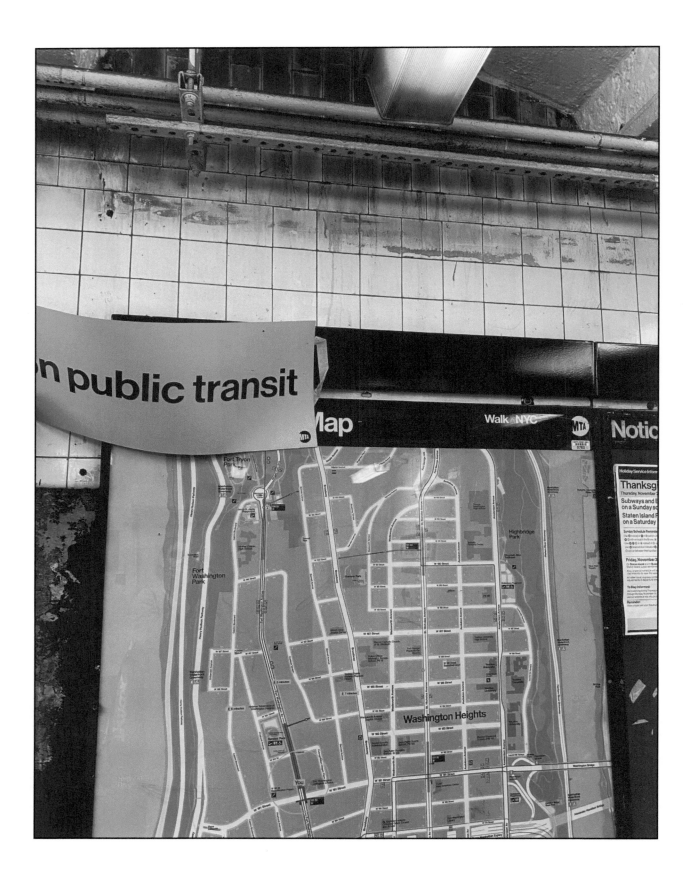

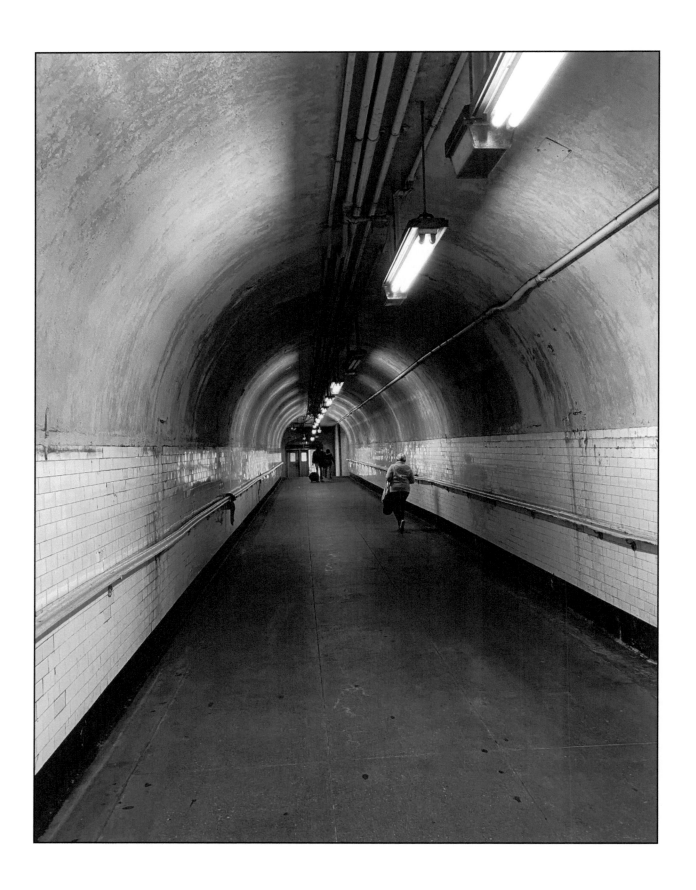

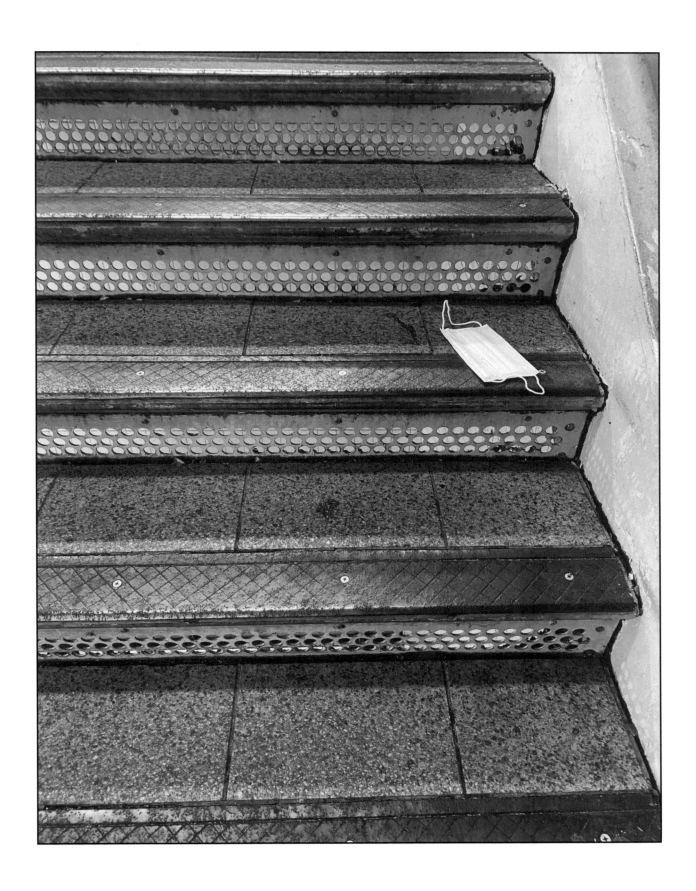

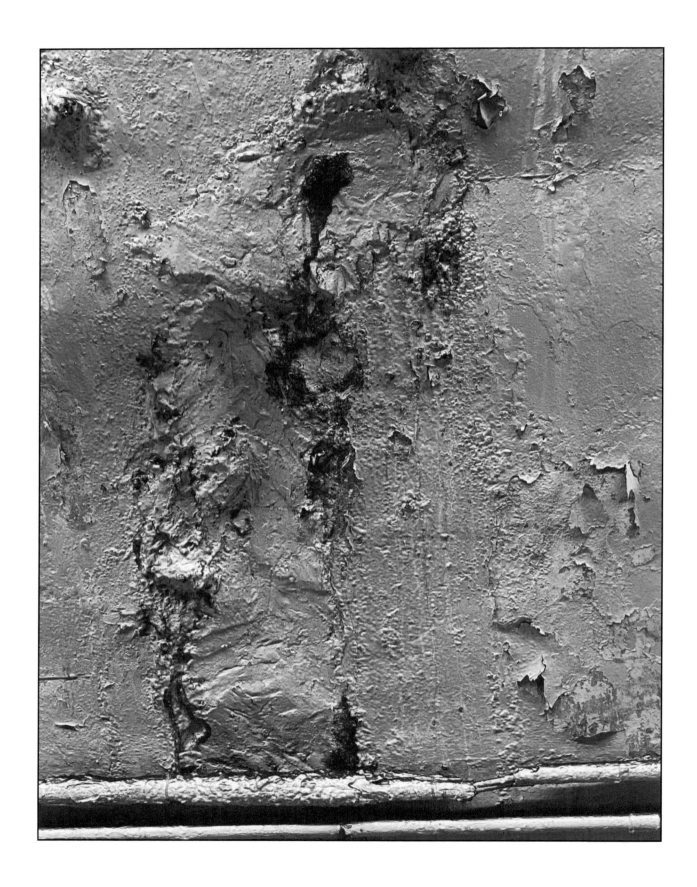

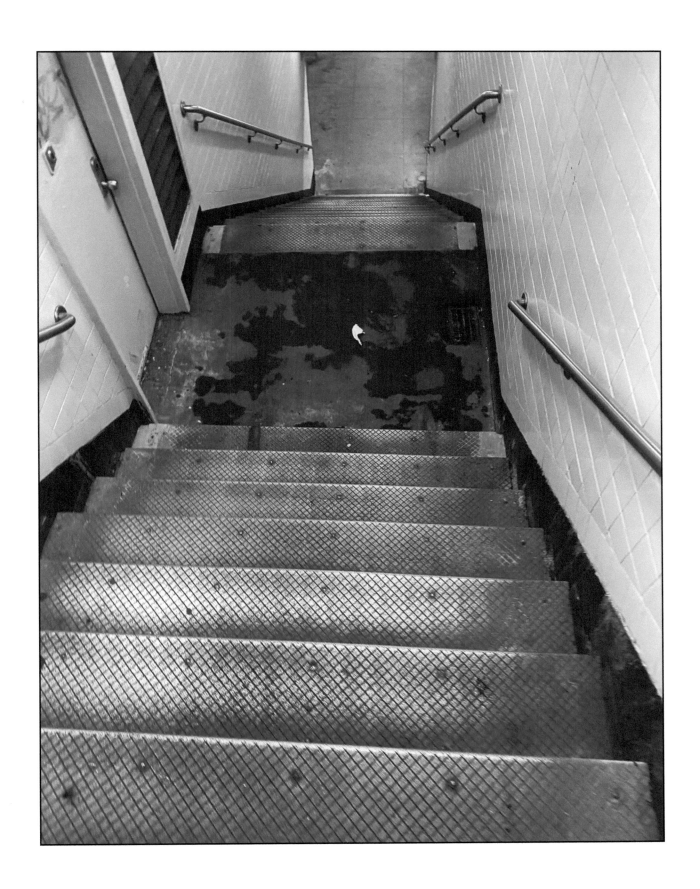

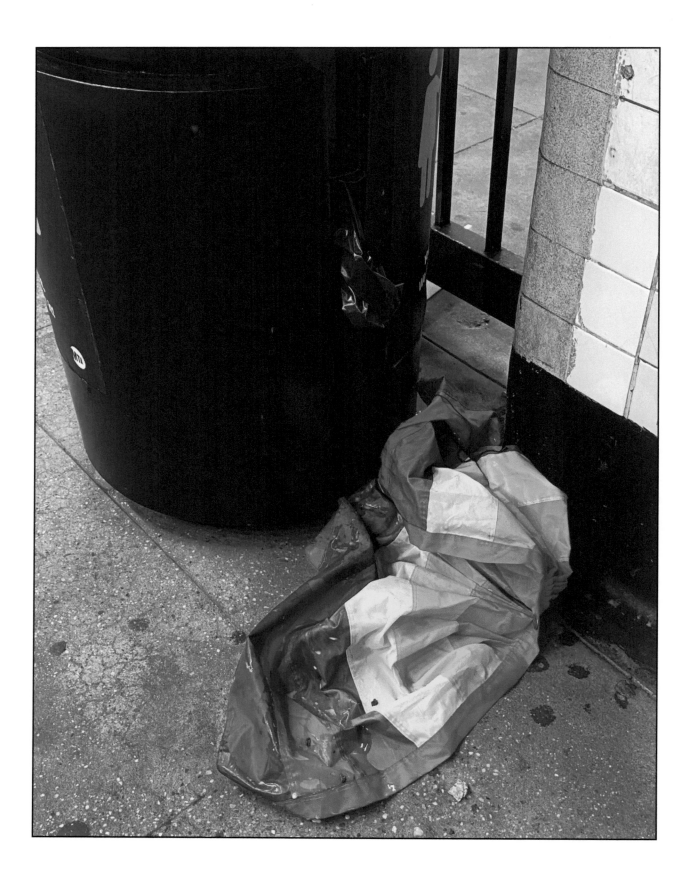

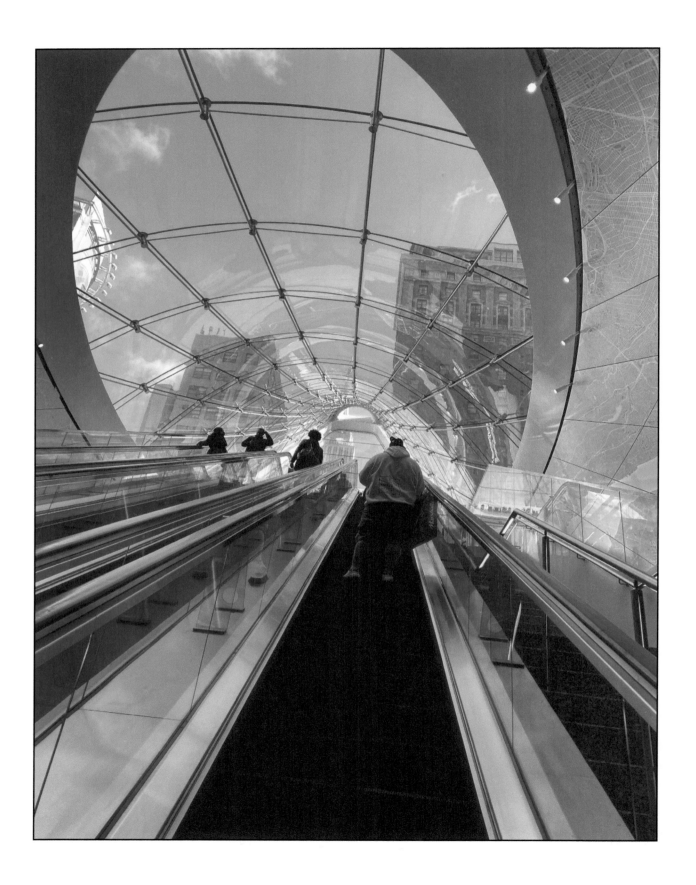

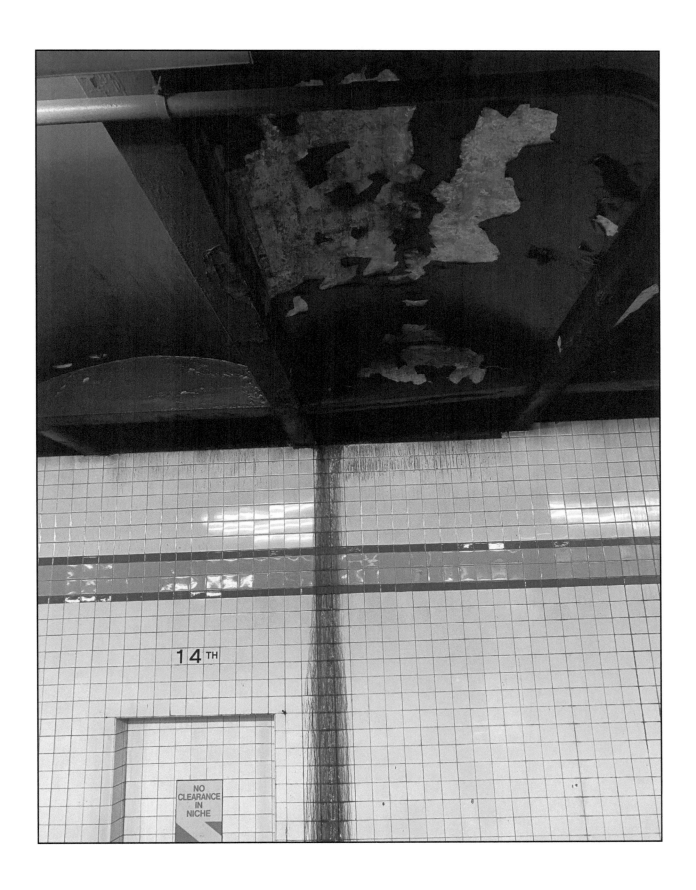

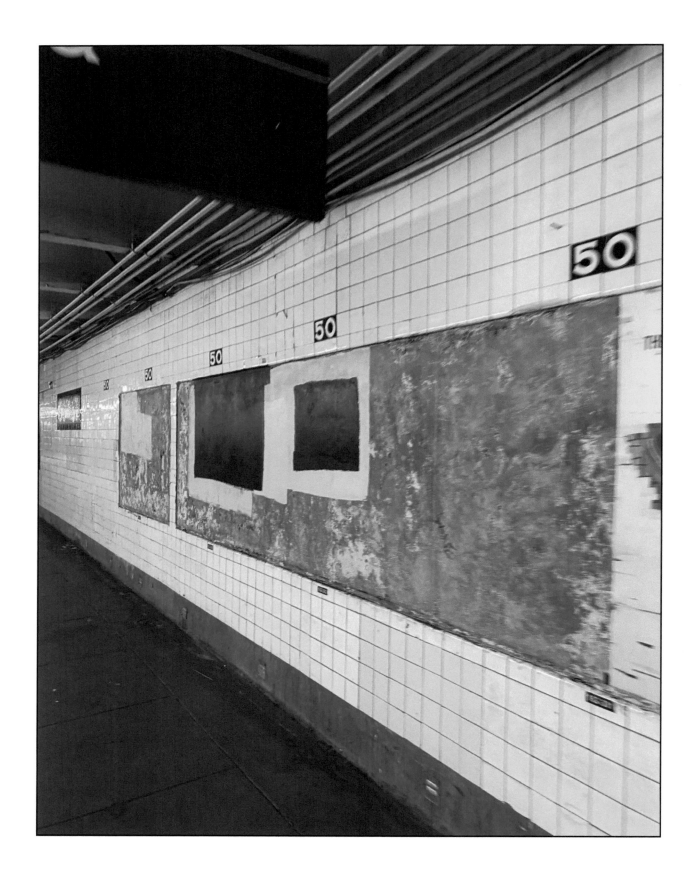

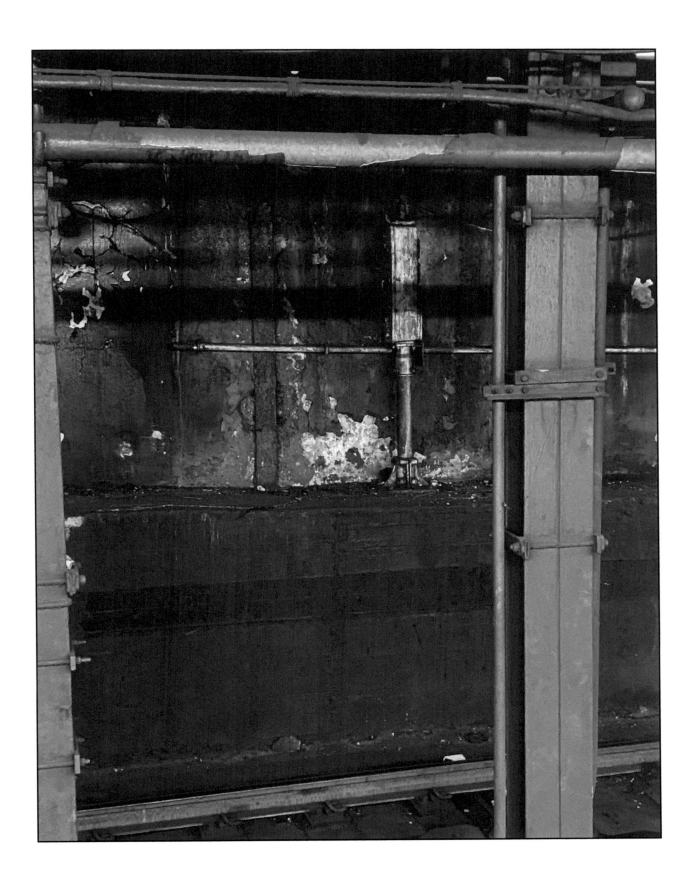

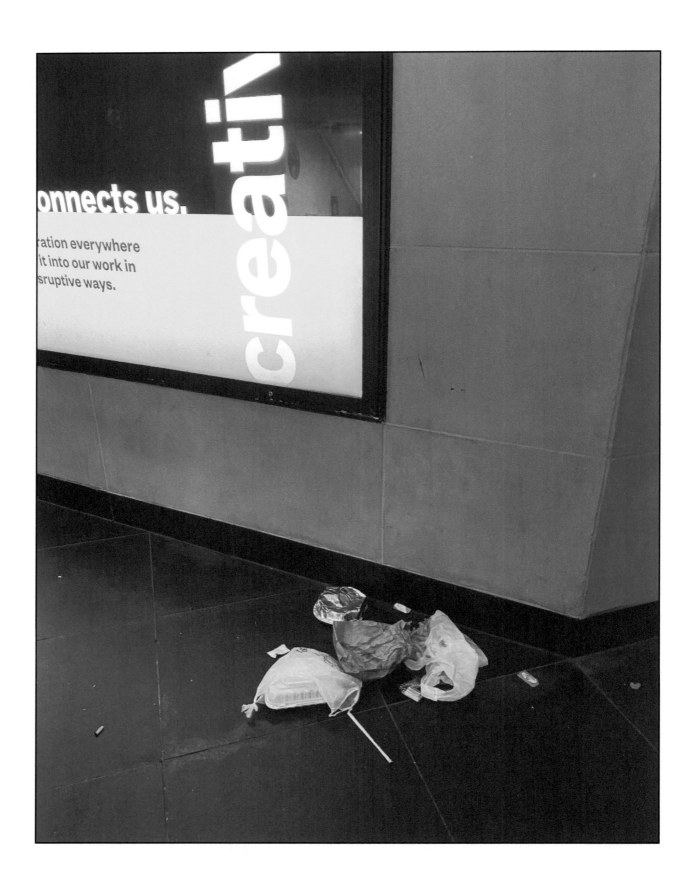

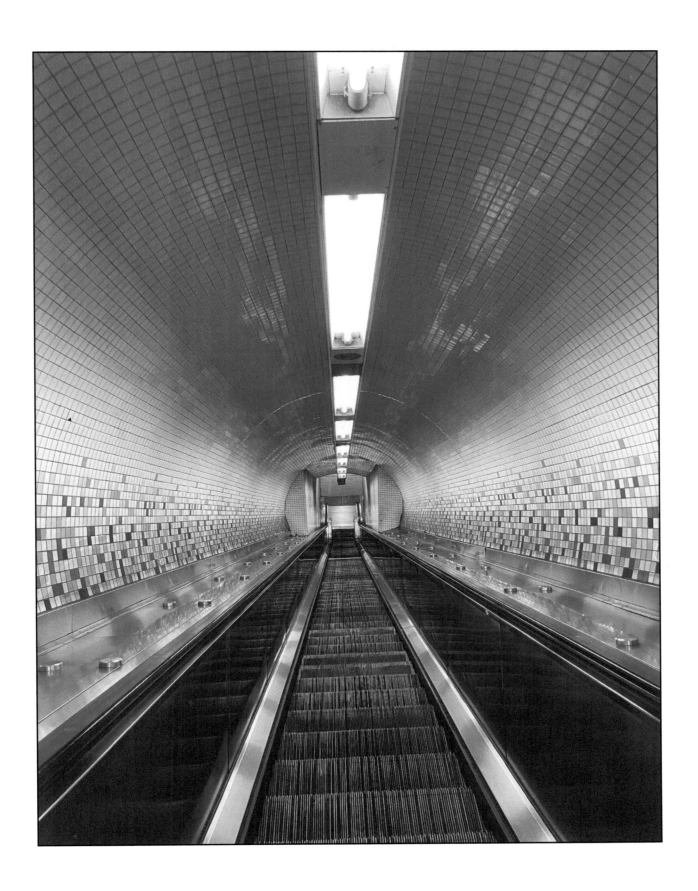

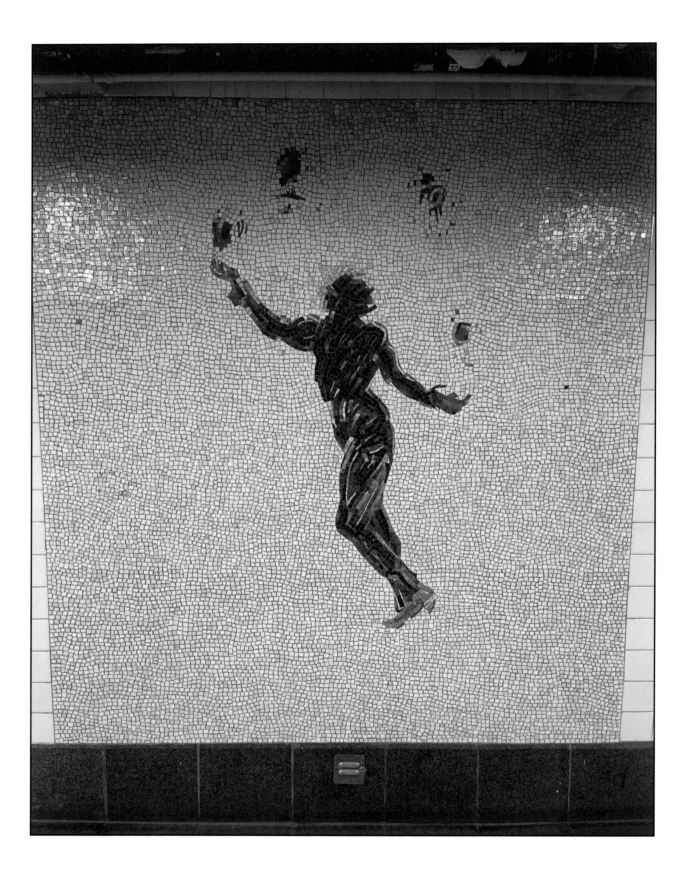

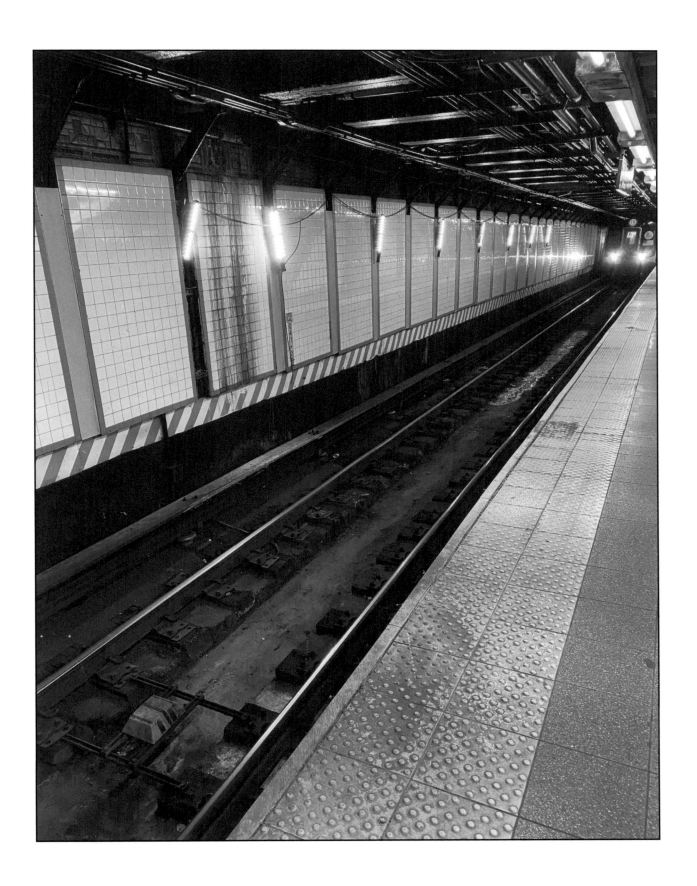

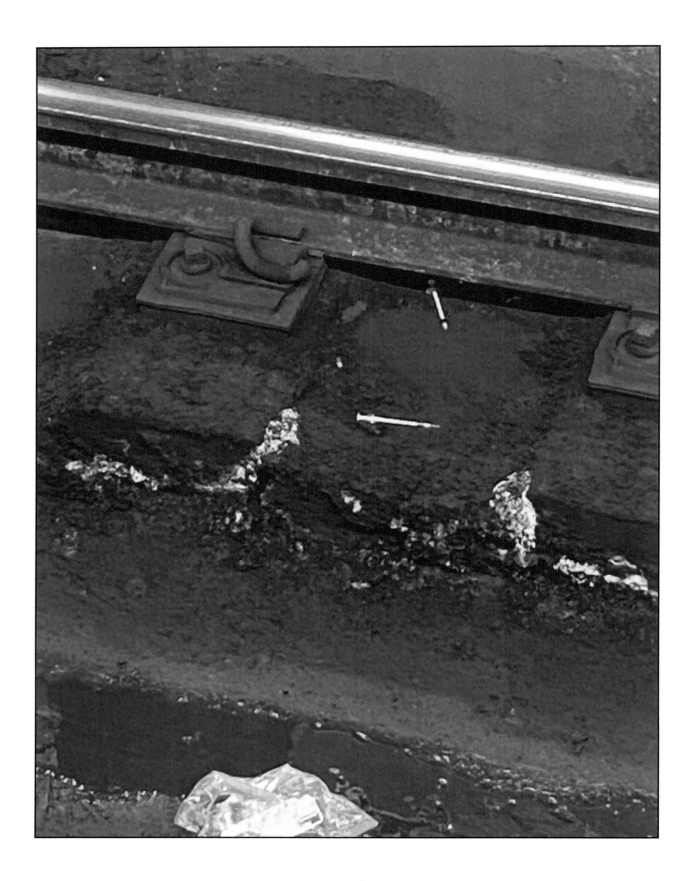

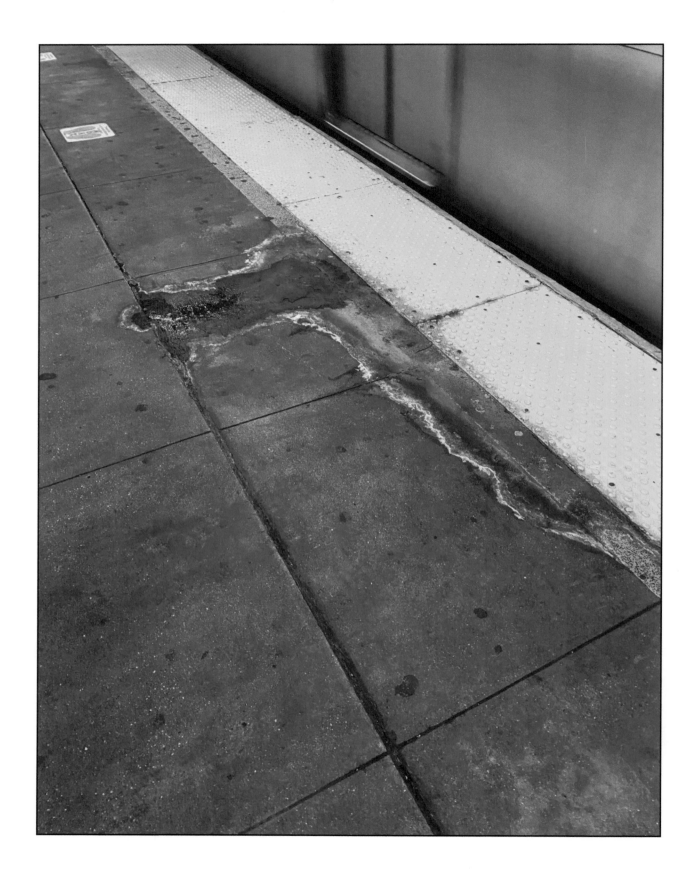

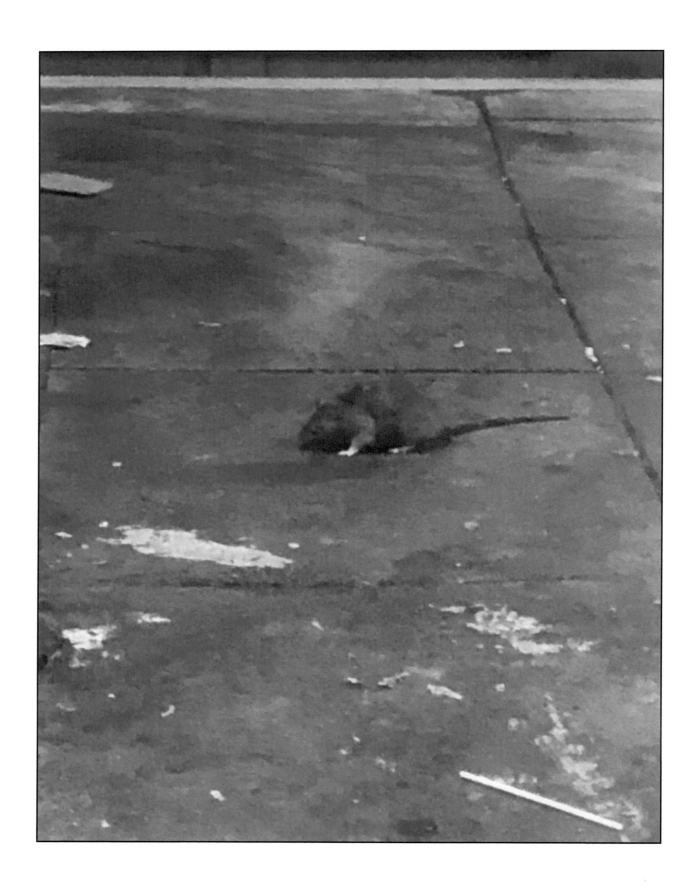

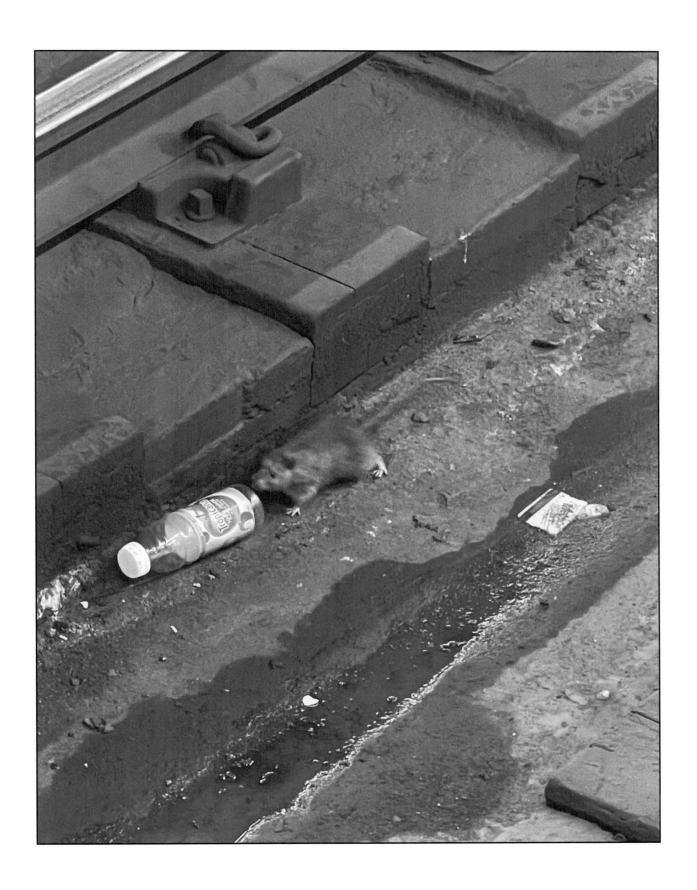

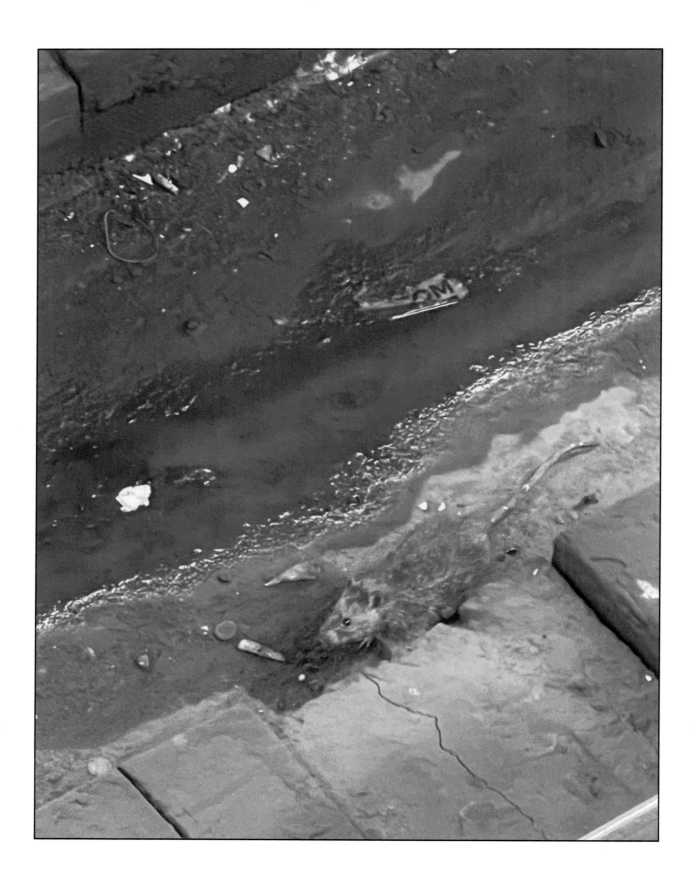

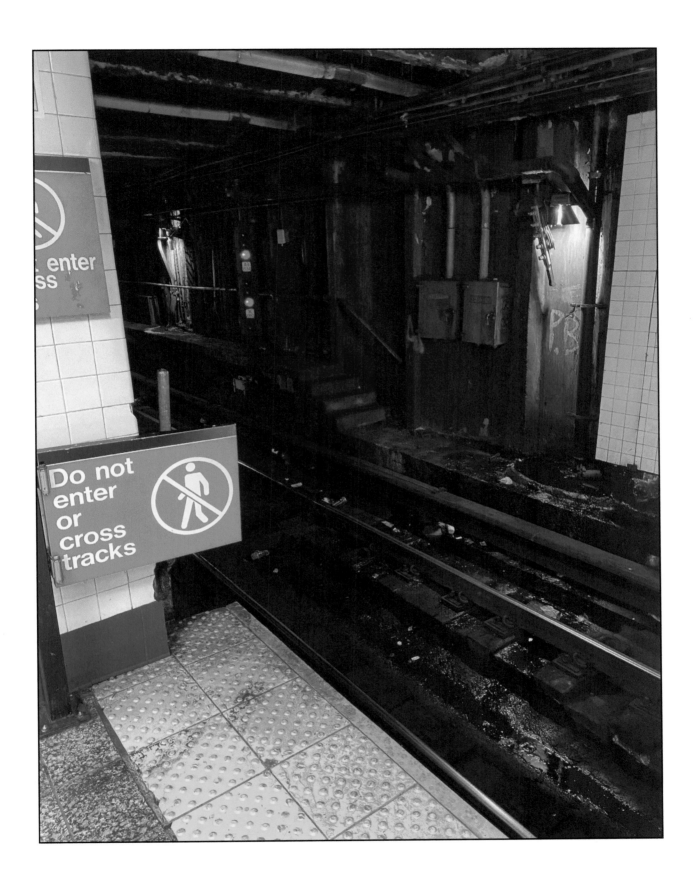

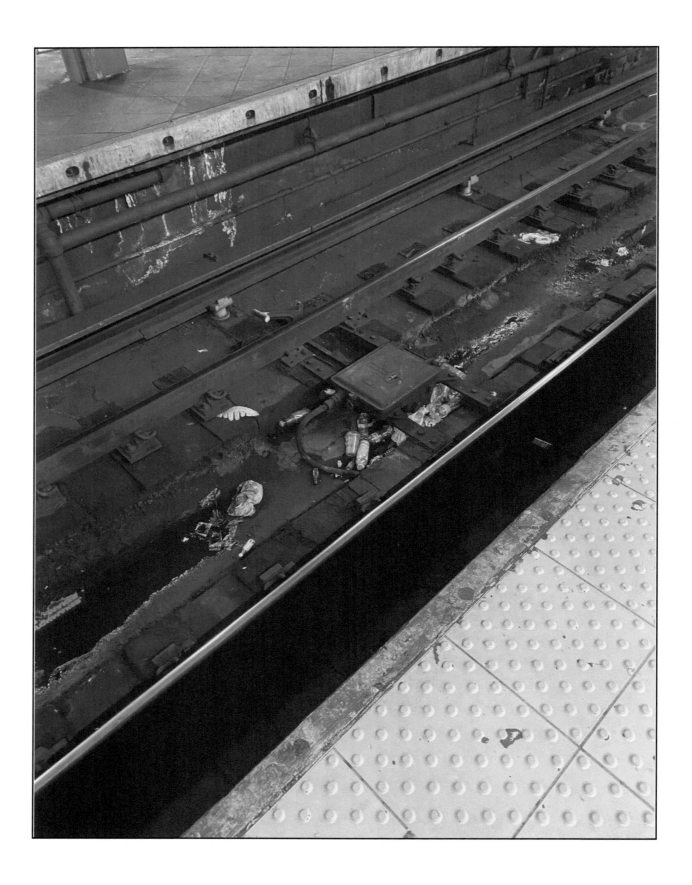

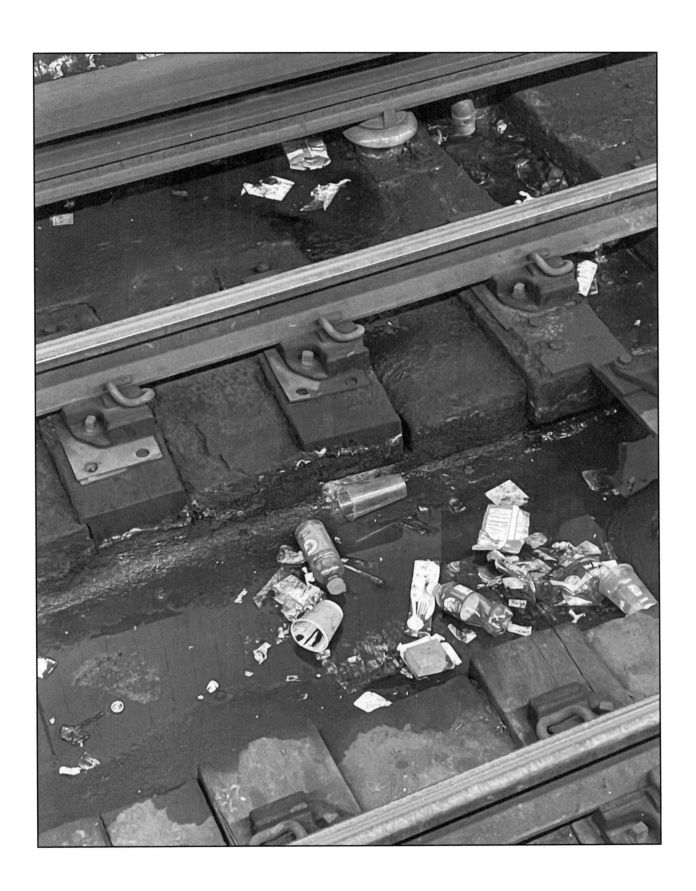

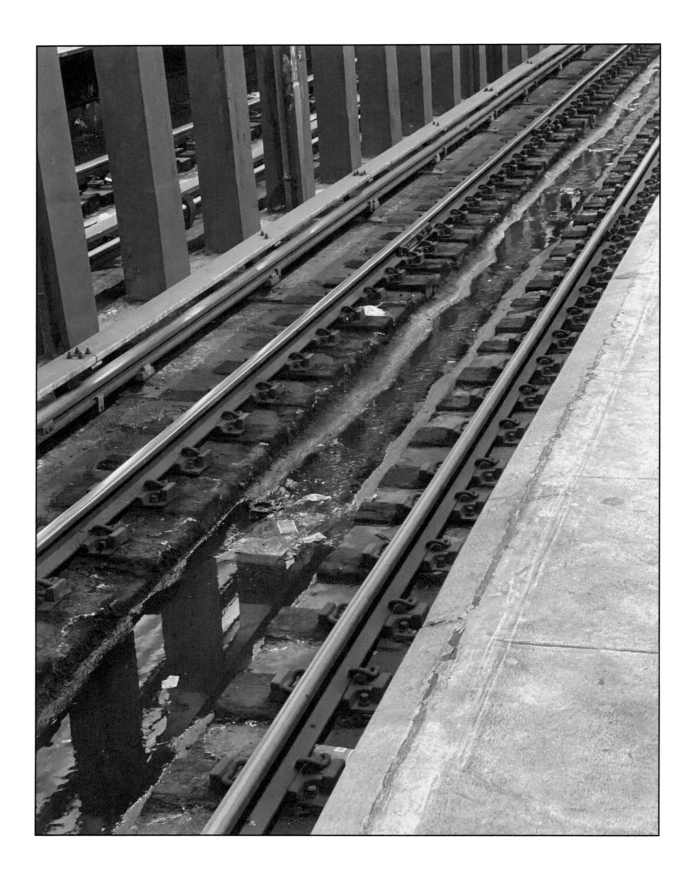

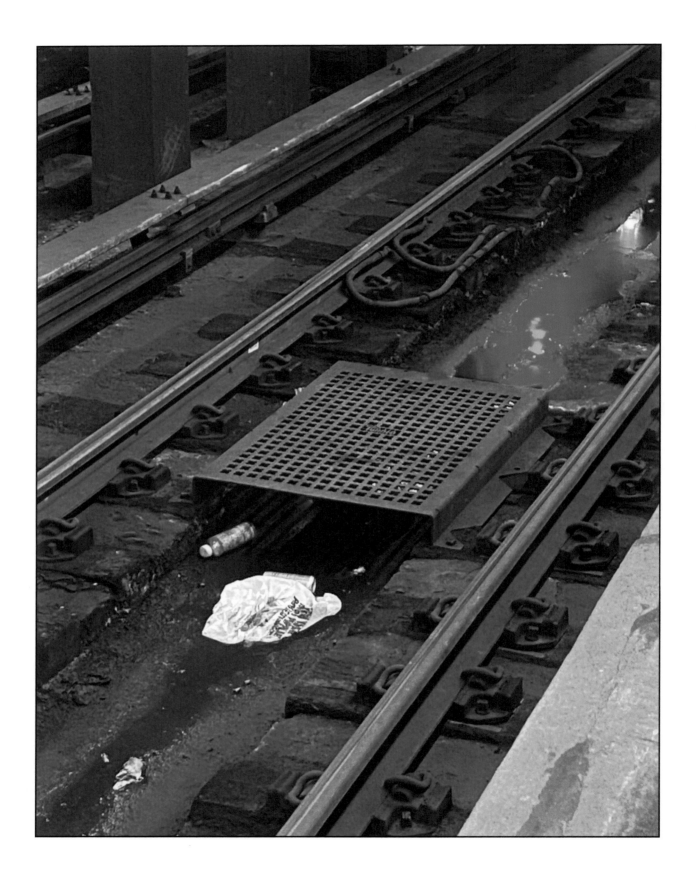

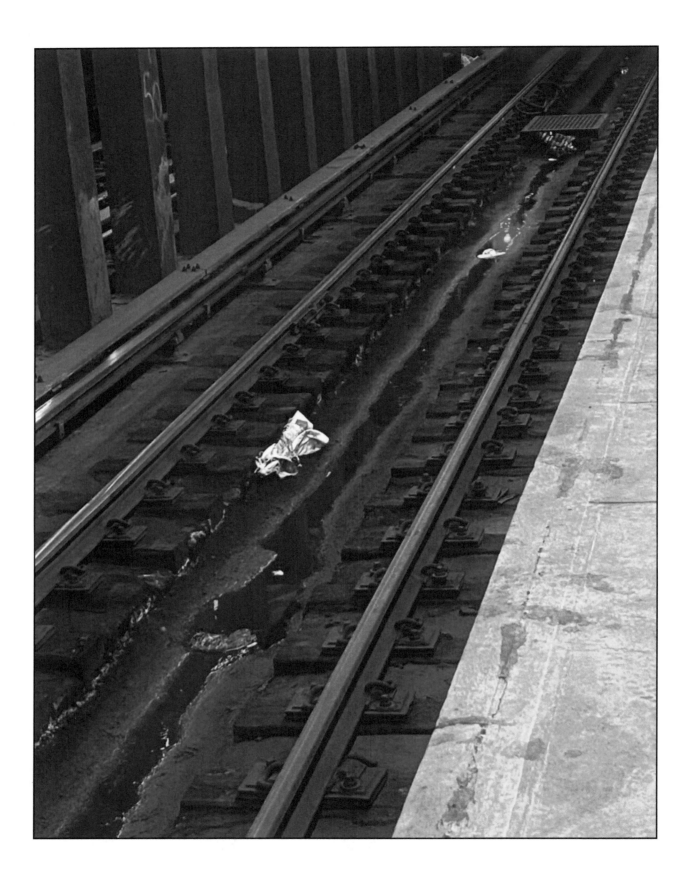

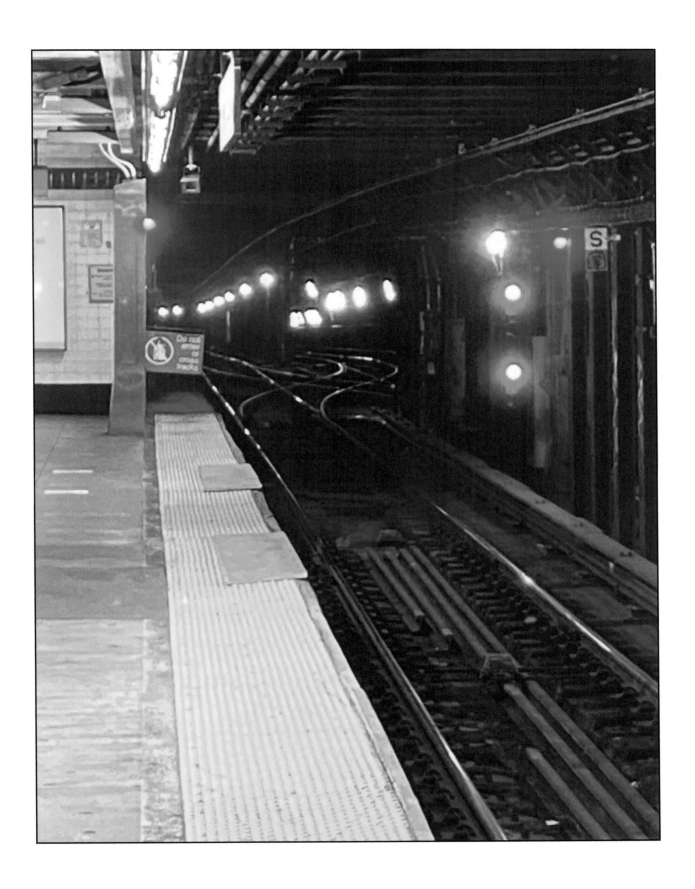

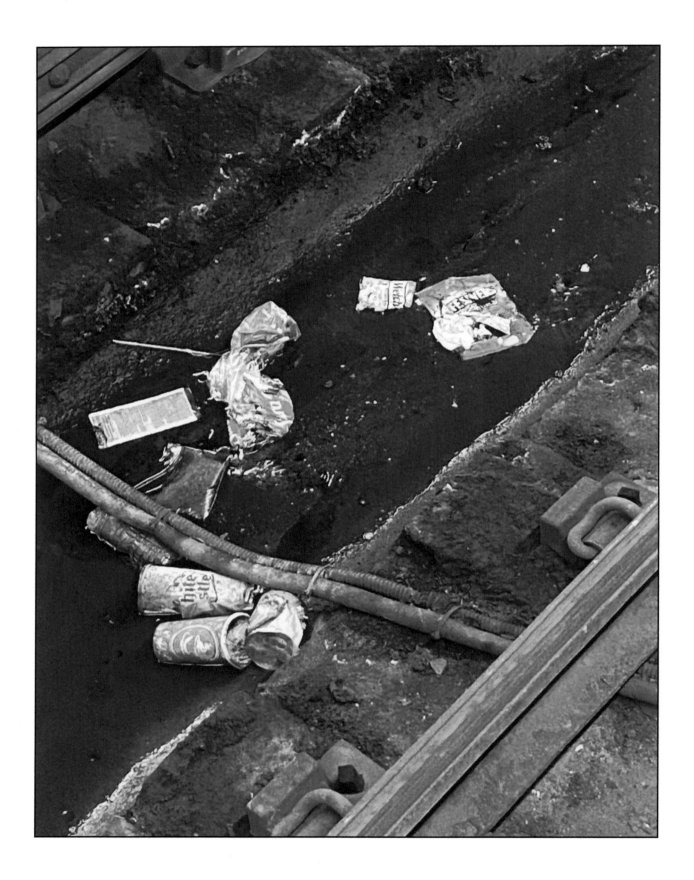

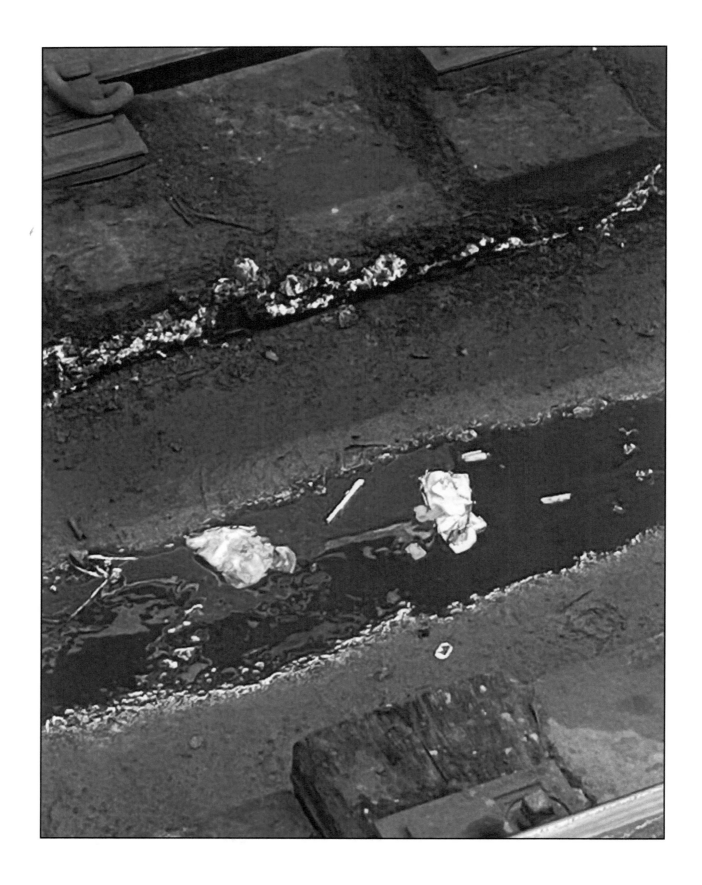

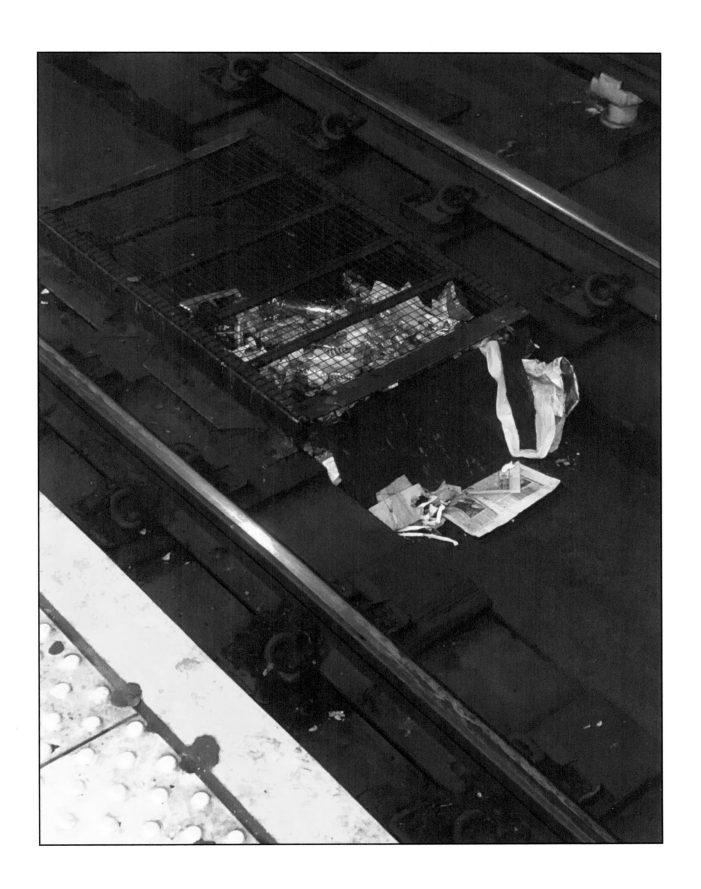

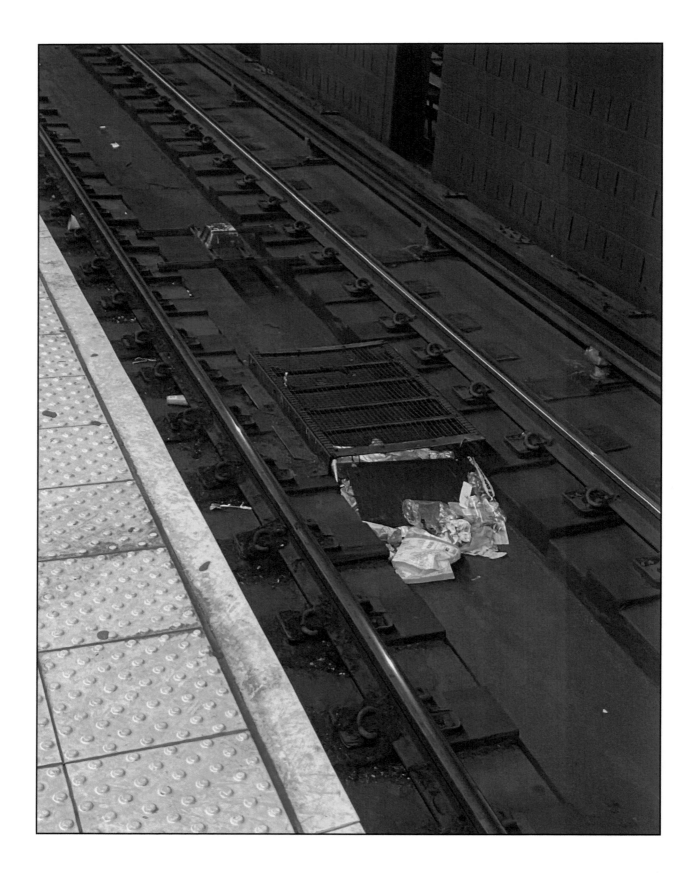

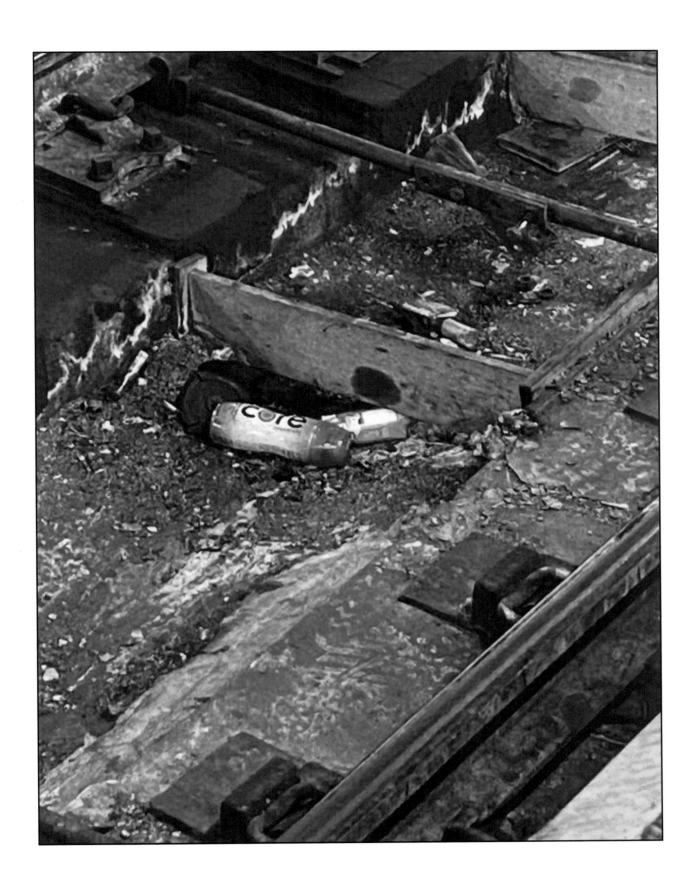

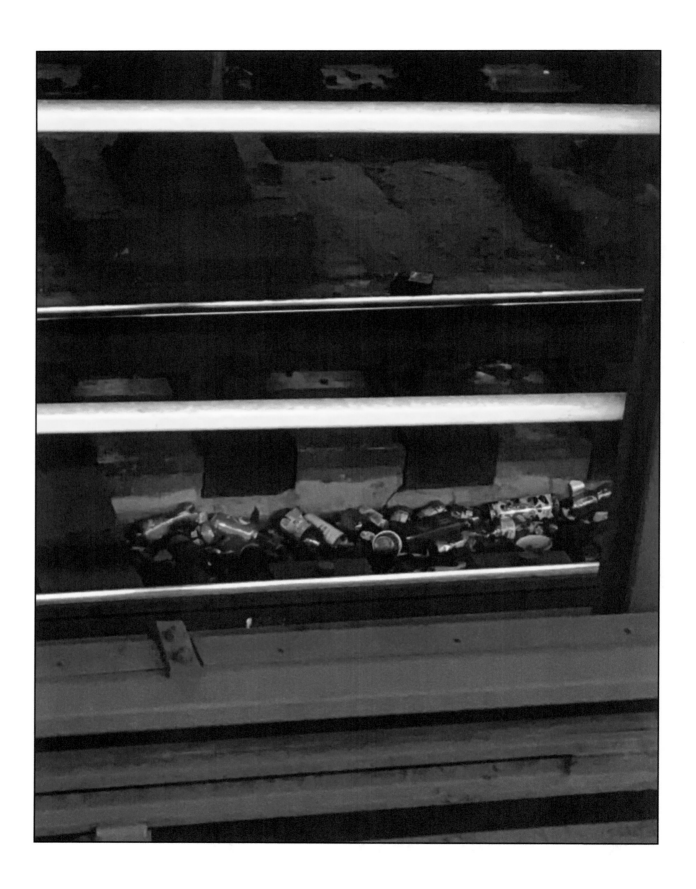

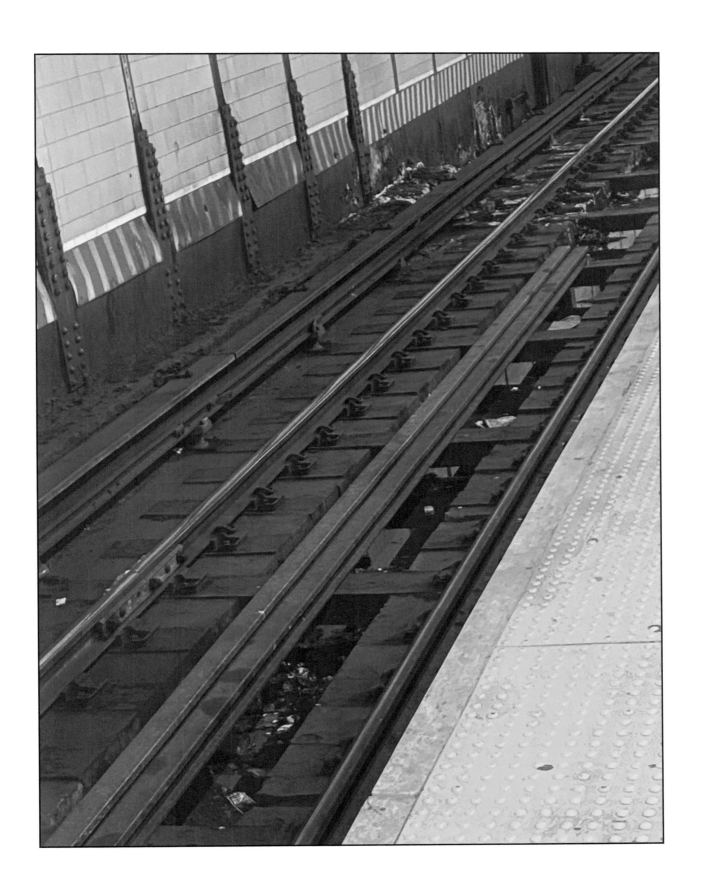

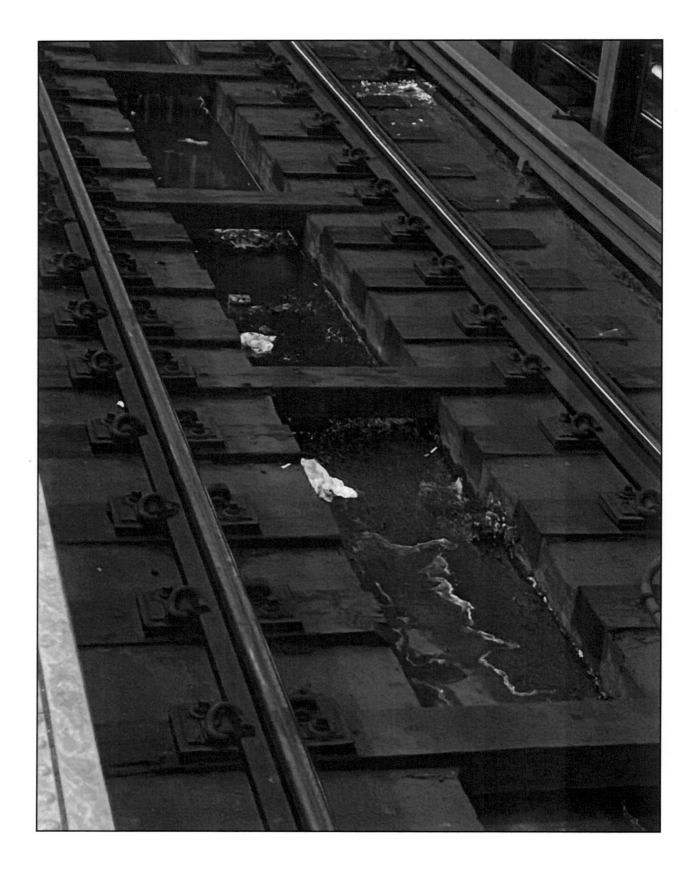

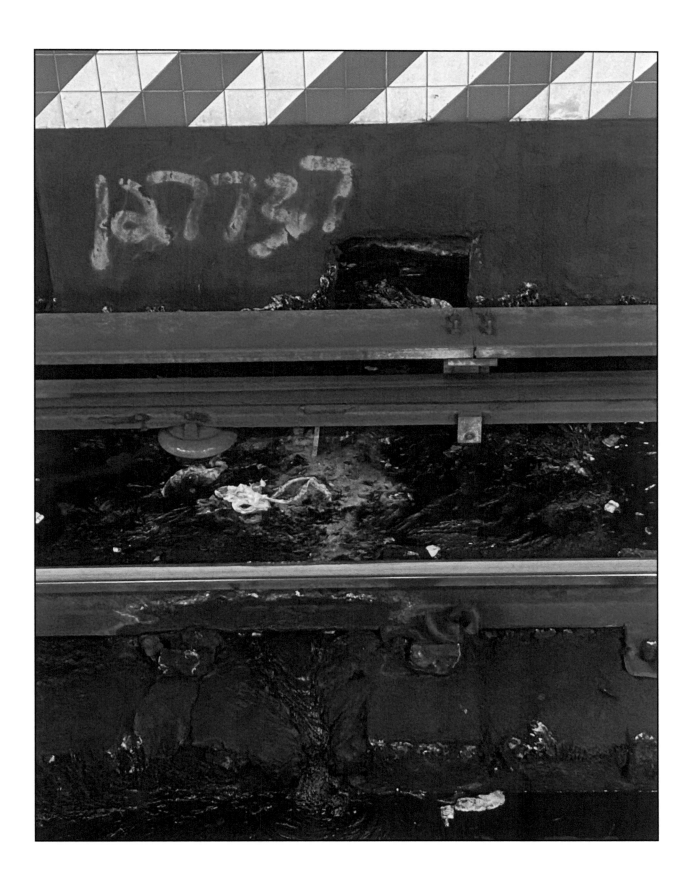

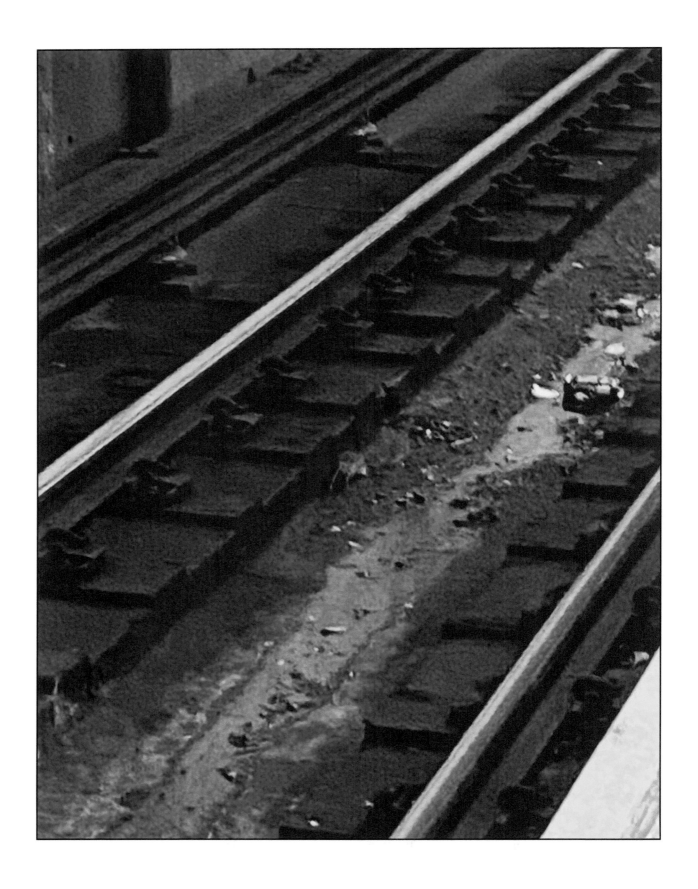

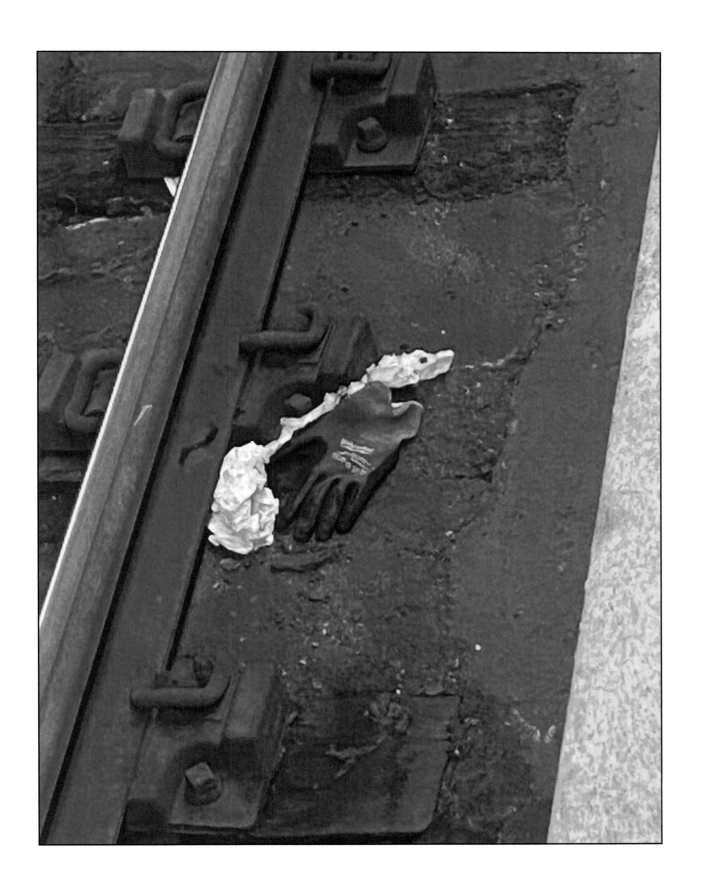

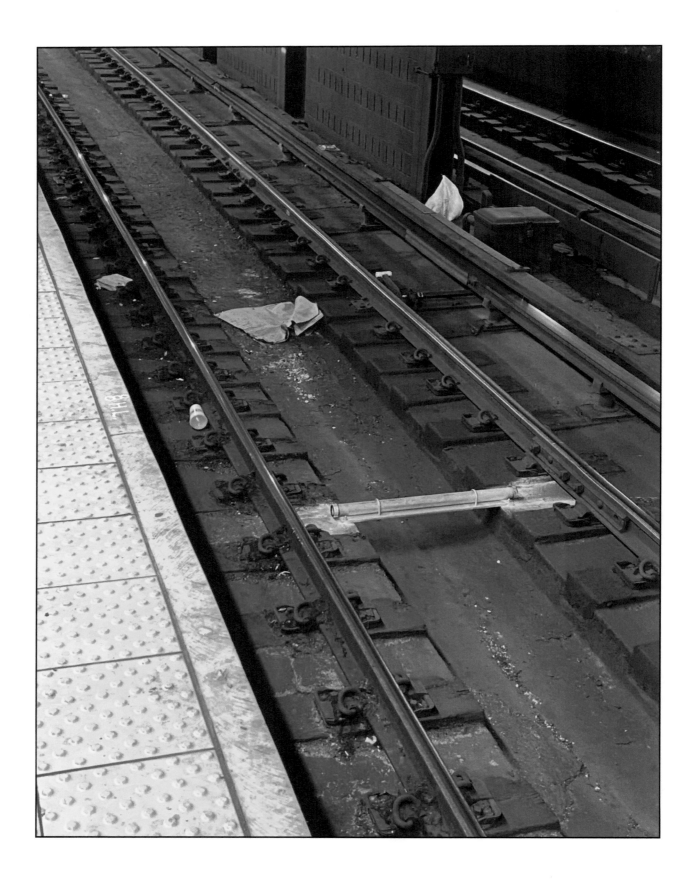

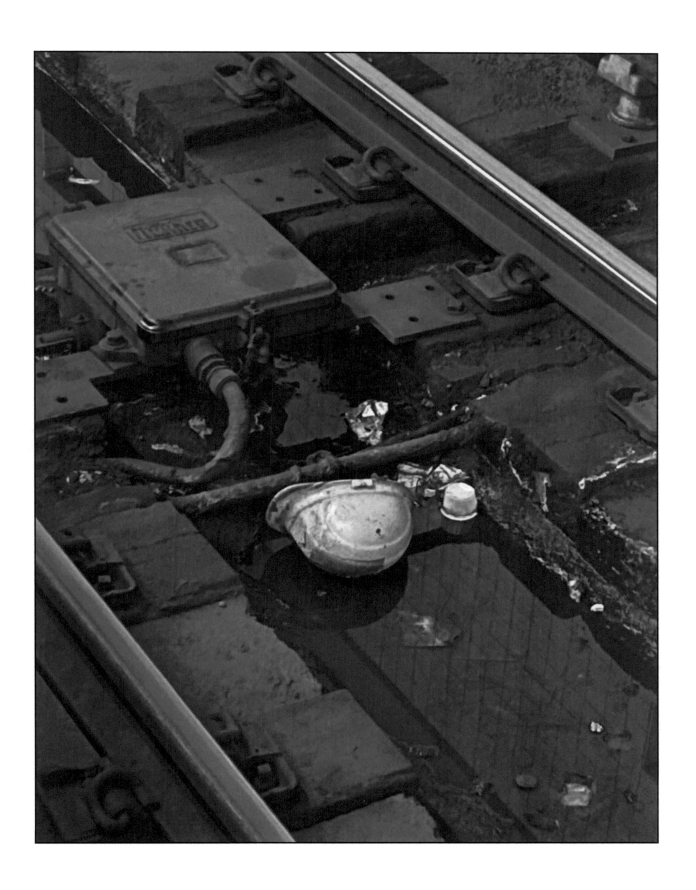

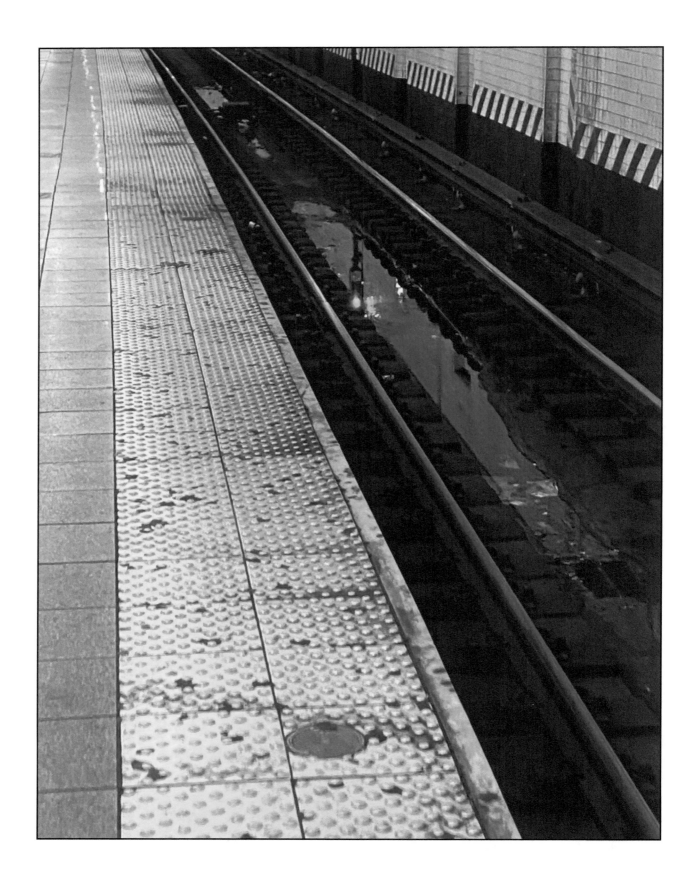

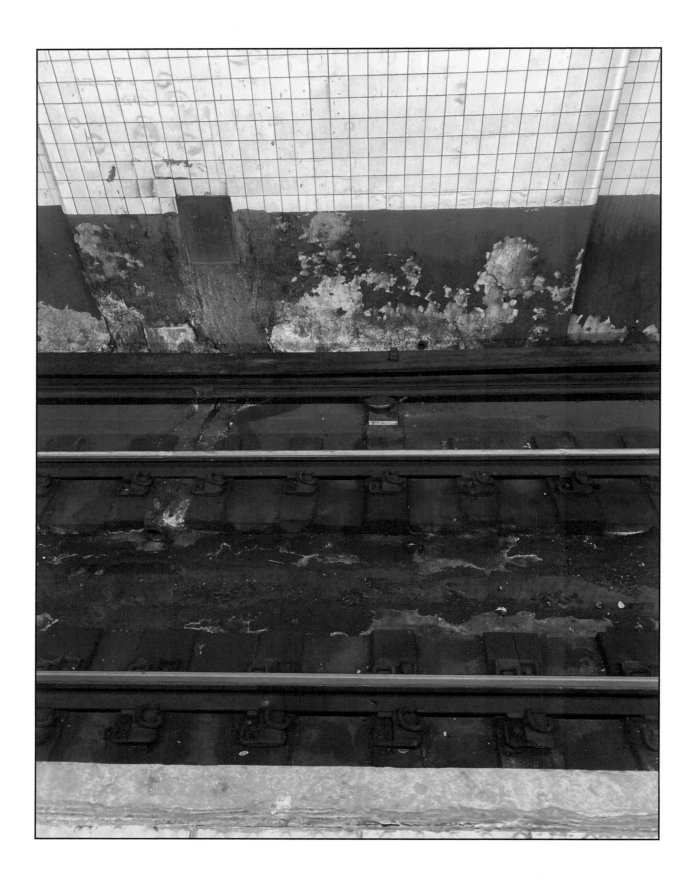

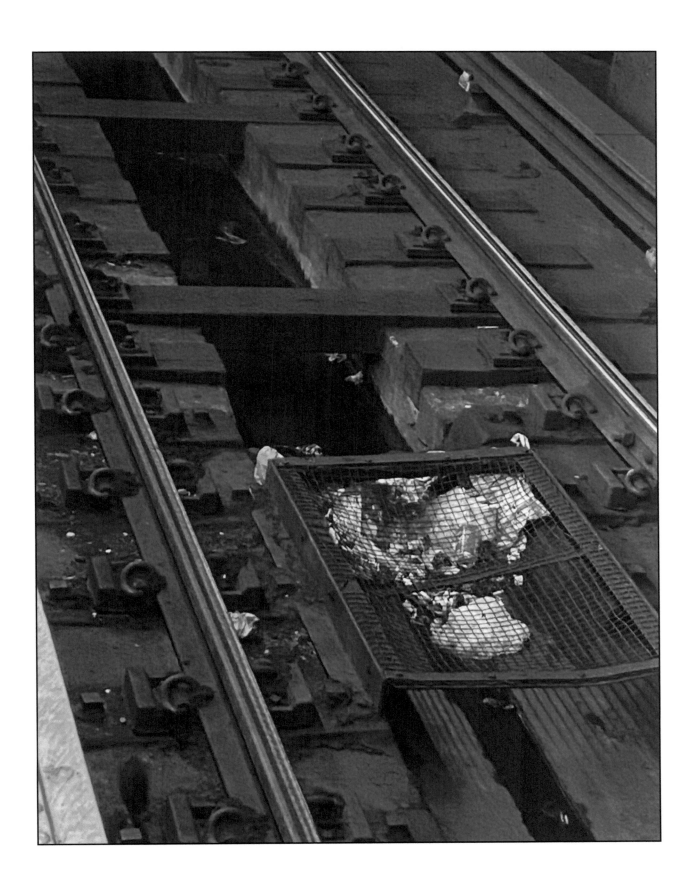